PENGUIN STUDIO
Published by the Penguin Group
Penguin Putnam Inc., 375 Hudson Street, New York, New York 10014, U.S.A.
Penguin Books Ltd, 27 Wrights Lane, London W8 5TZ, England
Penguin Books Australia Ltd, Ringwood, Victoria, Australia
Penguin Books Canada Ltd, 10 Alcorn Avenue, Toronto, Ontario, Canada M4V 3B2
Penguin Books (N.Z.) Ltd, 182-190 Wairau Road, Auckland 10, New Zealand

Penguin Books Ltd, Registered Offices:
Harmondsworth, Middlesex, England

First published in 1998 by Penguin Studio, a member of Penguin Putnam Inc.

10 9 8 7 6 5 4 3 2 1

Copyright © Graham Rawle, 1998
All rights reserved

ISBN 0–670–87775–1

CIP data available

Printed in Singapore

For Margaret

ACKNOWLEDGEMENTS

The author would like to thank:

THE MODELS: Rachael Kerr, Vicky Volckman, David Hiscock, Stella Bergen, Lucy Slater,
Andrew Leith, Ian Gardner, Chris Bolger, Brendan Walker, Roger Martin, Philippa Wingate,
Nick Wager, Mark Tempest

MAKE-UP AND HAIR: Katie Gibbon, Karen Hartley, Helen McKinnon

PROPS AND COSTUMES: Chris and Vinny at Panorama, Basil and Julia at Movietone Frocks

Jo Longhurst

Ursula Doyle, Rachel Heath, Francesca Dunfoy, Fiona Carpenter, Annika Roojun,
Jeremy Trevathan and all the lovely people at Picador; Michael Fragnito, Laura Healy,
Alix McGowan and all at Penguin Studio

Margaret Huber, Jeff Rawle, David and Anna Hiscock, Geraint Cunnick,
Ma and Pa Rawle, Huw Davies, Katherine Sheppard

And Georgia Garrett for commissioning the book in the first place

DIARY of AN Amateur photoGRAPHER

Rolleiflex

EXCELLENT PICTURE

Friday November 25th

Alistair at the Camera Club says we should all
keep a diary. It's the best way, he says, of
keeping a record of exposure times, shutter speeds
and aperture settings. In this way we can learn
from our mistakes. Film over-exposed; check
previous notes. Adjust accordingly. Simple.

So here's my diary. It will be a comprehensive
catalogue of my photographic achievements. I can't
wait to get started. But what to choose for my
subject? Alistair says it's up to each of us to
decide. He says we should all look to ourselves
for inspiration. Wonder what he means by that. I
think he might be giving us a clue without
actually telling us what to do. I might give him
a ring later at home. I've got his number.

We meet on Friday evenings at Aynsley Downe, my
old junior school. Alistair began our first
lesson (or get-together as he likes to call it)
by showing us some of his photographs. Marvellous
stuff. The pictures seemed so real I felt I could
just reach out and touch them. Alistair said he'd
prefer it if I didn't. Fingers and the glazed
print make poor bedfellows, apparently. I didn't
know that. Oh yes, there's a lot to learn about
photography. Lighting; developing; enlargements;
filters. Of course we won't get onto these things
until much later but it's as well to know what
you don't know.

There are eleven of us at the club. (Twelve if
you count Alistair) Don't know anyone's name
yet. (Except Alistair's) There are a couple of
young lads but most of them are around my age.
Quite a few are older actually, probably just
retired and looking for a hobby to occupy their
autumn years. Well, why not? You're never too old.

Everyone seemed to think it highly hilarious that
I don't have a camera. When I mentioned it to
Alistair the two young lads behind me started to
snigger and that set the others off. Alistair
xx said it wasn't as funny as it sounded. Apparently
some chap in the 1920s made several photographs
without using a camera. All done in the darkroom
and not a camera in sight. That put the sniggerers
in their place.

Nevertheless, if I'm to completex the first
assignment for next week's meeting I should
really think about getting myself one. Nothing
too fancy to begin with. A single lens reflex
with standard lens should do it. There's no point
in getting something cheap that won't do the job.
If I'm taking up photography as a serious xxxx
pastime, I might as well have equipment that will
do justice to my pictures.

I've been boning up on chapter 3, 'Choosing the
Right Camera', in The Handbook of Amateur xxxx
Photography by Dr Eugene Steinhauer, which I
bought yesterday from the second-hand shop near
the station, price £7.50. It's a weighty and
comprehensive guide covering everything from
lighting and composition to developing and
printing which should teach me everything I need
to know once I get started.

I'll go and have a look in Middleman's Photo-
graphic tomorrow. They seem to have a pretty
wide range of xxxxxxxxxxxxxxxxxxxxxxxxx second-
hand cameras. I noticed them the other day when
I was coming home from the library on the bus.
I would have got off there and then but I was
halfway through my counting game where I imagine
I am forced to have sex with every tenth woman
I see and was having a particularly good run
which seldom happens. Since getting on outside
Mr Toni in Crossley Heath I'd had sex with two
rather attractive housewife types, (one with a

short skirt and very good legs), and a
sophisticated-looking businesswoman in a
smart suit. The way things were working
out I was anticipating some measure of
success with the pretty young girl who
serves behind the counter at Patterson's
Patisserie. I always try to get her. I
sometimes close my eyes if I'm at number
eight or nine till I think we're at the
corner where the cake shop is before
opening them again. I suppose her figure
would be considered old-fashioned by to-
day's standards but I think she's lovely.
So of course I didn't want to get off the
bus with things going so well. Usually
it's a bunch of old biddies or gormless-
looking young office workers that I am
forced to pleasure.

Same day. 11.35 p.m.

I'm in bed now.
Another of Alistair's hot tips for the
budding amateur photographer is to cut
pictures we like from magazines or news-
papers. He suggests we keep these in our
journals and that by studying them we
will ourselves create better pictures. At
Camera Club meetings we will discuss our
visual references as a group.

I've just had a flick through TV Times
hoping to snip out a few good photographs
but there's nothing terribly artistic.
No black and white still lives or nature
studies, only pictures of people from
Coronation Street and Emmerdale. I'll
have a look through some of the local
papers tomorrow if the dustmen haven't
taken them.

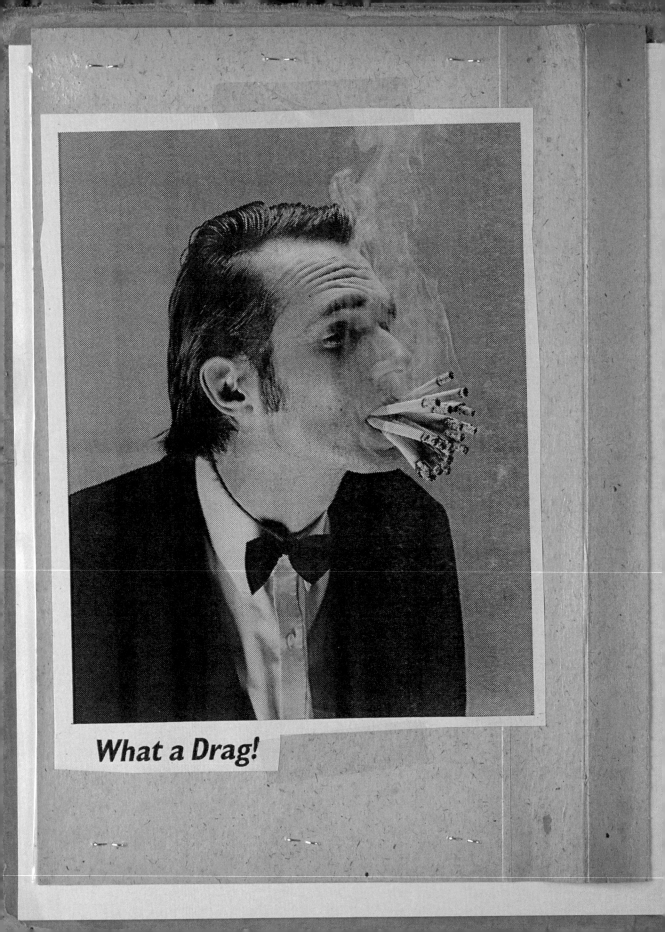

What a Drag!

Saturday November 26th

Dreadful night. Woke up with terrible chest pains.
The scissors I had taken to bed must have slipped
under the covers and I'd been lying on them. Got
up and put the light on to see what had happened
and found a perfect red imprint of the scissors
on my skin. Didn't get back to sleep until 5.40
so consequently overslept this morning.

Over breakfast I looked through a few old Whetford
and Crossley Gazettes but none of the pictures
struck me as Alistair's kind of thing. Quite a
good one of a man with 20 cigarettes in his mouth
(Guinness Book of Records hopeful) called 'What
a drag'. Alistair says titling a picture is very
important. It can make the difference between a
great picture and a mediocre one. He says he often
thinks of the title XXXXXXXXXXXXXXXXXXXXXXXXXX
even before taking the picture. I'll have to
try that.

With nothing much in the way of pictures I turned
to the Classified Ads. Haven't done that in ages.
Not since the incident over the woman with the
double mattress for sale. I promised the police
I'd stop after that. It was nice to scan the
columns again. One or two looked interesting.

LADIES SHOES for sale. White stil-
lettos. Size 5. Never been worn. £20.
Box 121.

I think we all know what that
one means. 'Never been worn'.
Are we expected to believe
this woman is a virgin? If
she's so pure, how come
she's advertising herself in the Whetford and
Crossley Gazette?

Wonder what this one's all
about. Better not get involved.

WILL THE GENTLEMAN who left a
package on the no. 73 bus last Friday
please contact Box 107?

this first simple rule.

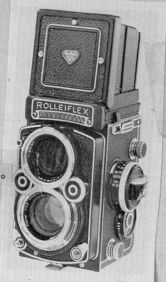

Then I found this one. I've
just looked it up in 'The
Handbook of Amateur Photography'.

The Rolleiflex 2.8F, for 120/220 film.

and 220 mm.

Rolleiflex 2.8F. This remarkable camera retains its popularity among
knowledgeable photographers for a very good reason: gadgetry aside,
it's the tops! Anyone who has ever had a Rollei in his hands can't
escape the hypnotic effect of this fine instrument, sharpened and
polished by years of experience. 80mm *Planar f/2.8* lens, *Synchro-
Compur* leaf shutter with speeds from 1 to 1/500 second. Waist-level
viewing with *Rolleiclear* focusing screen, central microprism, automatic
compensation for parallax, eye-level sportsfinder. Single-stroke crank
advances film and sets shutter. Automatic film loading and frame count-
ing. Can use 35mm film (with adapter). Built-in exposure meter cross-
coupled (for EVS use) to shutter and lens aperture. There is a 3.5F
model, and a less expensive *Rolleicord VB* which uses only 120 film, but
has automatic parallax correction.

Could be outside my price range. If I wanted
something cheap I'd be going for one of those XX
little instamatic jobs but they're XXXXXXX really
just for quick family holiday snaps and aren't
sophisticated enough for the serious amateur
like myself. Whereas the Rolleiflex 2.8f sounds
just the ticket. I wonder how much it is. I'll
give the number a ring.

Same day. 5.10 p.m.

The man who answered didn't seem to know much
about the camera. Sounded a bit dopey to me. I
don't think he'd know a synchro-compur leaf
shutter from his elbow. He had no idea about a
price. I suggested £100 to test the water and he
agreed. Should have offered £50. Anyway, I'm
going to pick it up later, (having first satisfied
myself that it is in full working order of course).
He lives in Wooton Green so I'll have to XXX
change buses.

Same day. 7.31 p.m.

Well I've got it. It's in excellent condition and
it comes in a handsome leather carrying case.
(though the strap needs some attention). The man
seemed strange. Not quite the full shilling, I
didn't think. He lived in a tiny bed-sit which
smelled of brussels sprouts and was crowded with
cheap ornaments. There was even a mouse in a
brandy glass with a cat climbing up it like we
used to have. I can't imagine how he came by that
camera, he doesn't seem the type.

Sunday 27th November

Spent much of the morning trying to figure out the
workings of the Rolleiflex. It's a beautiful piece
of craftsmanship with lots of buttons and levers
which I haven't quite got the hang of yet. Of
course there are no instructions. I managed to
flip up the top which forms a sort of hood so when
you hold the camera at waist level you can look
down onto the ground-glass focusing screen. This
reflects the image back the lens sees but back to
front like in a mirror. I've already had a trial
run with it round the house - without film of
course - but it's pretty tricky because as you
move the camera one way, the image moves to the
other. This could be particularly difficult with
a moving subject. i.e. speeding motorcycle
travelling left to right actually appears to be
going right to left. I expect it's something I'll
get used to. Good job it's not upside-down as
well. That would be too confusing.

Same day. After lunch. (Cockaleekie soup with
crackers)

I think I'll have a go at loading film in my
camera. I haven't actually got any film yet so
this will be more of a practice run. It pays to
be prepared and a camera without film is like a
gun without bullets. (Professor Steinhauer)
Luckily I've already studied the chapter in the
handbook on loading film so I'm all too
aware of Professor Steinhauer's golden rule
regarding this operation. "First make sure check
to make sure there isn't already film in the
camera." Well it may sound obvious but you'd be
surprised how many precious shots have been
fogged owing to the careless non-observance of
this first simple rule.

I've just checked the little window on my camera which shows a number 2. This means there is film in it, and one shot has been taken. I wonder what's on it. I'd like to take it out but I'm not sure how to open the back of my camera and I don't want to ruin the film. I'll take it in to Middleman's Photographic tomorrow to see if they can help.

Later on I took my new book and the Rolleiflex into the bedroom and had a lie down. (Still tired from last night) I must have dozed off because I had another of my chemist shop dreams.

Chemist Shop dream. No.61.

This time I am waiting to see the owner about a job. A man in a white coat says his wife will be conducting the interview and that he will go and see if she is ready to see me. I think I'm too early. He goes out to the back and I stand looking out of the window trying to imagine what it would be like to work there. I wander round the shop looking at all the stuff. The stock seems really old.

Some young school-leaver types dressed in suits enter having also come for the job. I haven't dressed up at all, in fact I am only wearing a T-shirt and my underpants. They sit down and wait. I don't want to hang around with them so I go to the back of the shop in search of the chemist.

I call out hello but there's no reply. A curtain hangs over a doorway and behind it there is a flight of stairs lined with cardboard boxes which I take to be stock for the shop. There is a room at the top of the stairs and from it I can hear what sounds like a woman breathing heavily. The door is ajar and I want to see what is happening. I figure the vulnerability of her situation will allow me to take a look without being confronted.

When I put my head round the door I see a woman I
assume to be the chemist's wife lying on the bed
in her nightdress. She is writing something on
the wall with a piece of chalk held between the
toes of her right foot. I can't see what she is
writing but I stop to stare at her for a few
minutes until she looks directly at me when I
run down the stairs and out into the street.

When I woke from the dream I realised Mrs
Eckersby next door must have had a visitor be-
cause I could hear voices through the wall. One
was a man's voice so I don't know who that
could be. Seemed more like it was coming from
downstairs so I got under the bed and put my
head to the floor but couldn't make out what
they were saying.

Monday November 28th

More snow last night. Possible theme for my
photo assignment? 'Walking in a Winter ▓▓▓▓▓▓▓
Wonderland' Or is that a song title? Anyway I
don't want to rush it. "One of the most valuable
things in a photographer's camera bag is
patience." (Professor Steinhauer)

Remember that the choice of subject is the most important thing of all.
The owner of a camera with a focusing screen, especially if it be a reflex (in
which the picture is right side up), has the best equipment for choosing his
subjects. From the multitude of possible subjects each photographer must
choose those that appeal most to him personally, for if he restricts himself
to the obvious ones he will succeed only in producing a series of picture post-
cards.

was only on the market for a year or two as I
recall. I wonder what's on that one exposed frame."
I wondered too.

I've just checked the little window on my camera

According to The Amateur Photographer's Handbook I
only get 12 shots on one film so I want to be sure
I've chosen the right subject, be it still life,
portrait, landscape or figure study. (Nothing
wrong with the naked human form) I must
do what feels right to me. Plenty of
time to decide. In the meantime I can
bone up on the practical side, and
there's plenty to learn in that
department I can tell you.

Michael Whittingham
67 Warmander Avenue
Whetford

Dear Box 107,

With reference to your advertisement in last
week's Whetford and Crossley Gazette, I
believe I am the gentleman to whom you refer.
I'd be grateful if you could contact me with
details of how I could collect the said
package.

Yours faithfully,

M. Whittingham

CARBON
COPY

Had two scotch eggs and a jar of pickled beetroot
for my lunch then took the bus over to Middleman's
Photographic with my camera. During the journey I
 was very nearly forced to have sex with that
lovely creature from Paterson's Patisserie until
some frumpy old woman suddenly got out of a car
at a crucial point in my counting and I had to
have her instead.

Mr Middleman was very interested to hear about my
purchase and wanted to know all about how I'd come
by it. He could tell by the high quality camera
that I was a serious semi-professional. No
instamatic nonesense for me.

He must have noticed the name and address label I
stuck inside the camera case last night.

"Whittingham. I knew a Whittingham once," he said.
"Was your mother Joyce? That's right. Used to live
on Inverclyde Avenue. She was a bonny woman, your
mother. Yes, very striking, very photogenic. I
expect you've got some smashing photos of her in
her heyday."
It seems my father was less memorable. He couldn't
quite place him.
"Now remind me, what was his line of business?
Professional gentleman, wasn't he, doctor or some-
thing? Or was he a scientist, I can't quite
remember?"
I told him he worked at Binson's making ice-cream
wafers.
"Mm, yes. Vaguely. Little fellow, wasn't he? Yes.
You don't take after your old man then?"

He asked if I knew there was film inside the
camera. I told him I did. He wound the film on
before carefully opening the back and removing it.
There was a tab of gummed paper at the end of the
roll which was old and discoloured. Mr. Middleman
gave it a good lick before smoothing it round the
film. He stood the film on the counter.

"Hassard. Blimey, that's an old one. Hassard
stopped making film in 1960. Couldn't compete
with the big boys, see? This one, the UltraPan
was only on the market for a year or two as I
recall. I wonder what's on that one exposed frame."
I wondered too.

He said I should get it developed. I explained
that it wasn't really mine to develop, that it
actually belonged to a man in Wooton Green.
"Well it's yours now. It's in your camera."

I've never liked the look of those one hour
printing places, so it's probably just as well
'Foto Fast' don't do black and white film. As Mr
Middleman pointed out, most commercial processors
won't handle it, you have to go to someone a bit
more specialised. Well, quite, I thought.
Besides, who wants to get their pictures back
that quickly? Hard to work up a sense of
anticipation in an hour. Anyway, I wouldn't feel
comfortable entrusting my film to someone who
can't spell their own name.

Mr Middleman had suggested Brumfit's Pharmacy on
St Alban's Road where he said they still did black
and white and were very helpful. I'd planned to
make my own selection from Yellow Pages but he
seemed most insistent. I knew where it was.
Brumfit's was the chemist shop where we used to
get our holiday snaps developed when I was little.
I once had my picture taken there too. Mr Brumfit
was a bit of a semi-professional and had a small
studio above the shop where he did portraits,
passport photos, that sort of thing. After Mum died
and Dad left we never really went there because
Nan swore by Boots the Chemist for all our
processing needs. In fact I hardly remember going
to St Alban's Road shops after that. Nan was very
keen on the new shopping precinct which by then
had opened by the station.

It was strange going back to my old neighbourhood.
Must be 30 years since I've been down there.
Walking down Inverclyde Avenue, it seemed like the
road had been narrowed because the houses on either
side appeared closer together. Our house had been
painted a different colour and it had a new front
door but the chevron-shaped flower bed that my

father had cut into the lawn was still there.
Nobody was about. No cars. It was extremely quiet. I
walked past Mrs. Lowry's the piano teacher. XXX
XXXXXXXXXXXXXX The Ingram's, that was still the
same but smaller. As I passed the house on the
corner where the little boy used to stick his arms
through the gate, I noticed a doll wearing a tiny bra
and pants lying face down on the front lawn. I'm not
sure what made me do it but after checking that no-
one was looking, I stepped into the garden, picked
up the doll and slipped it into my coat pocket.

When I reached St Alban's Road shops I thought at
first that I was on the wrong street but then I
started to recognise things. Brumfit's actually
didn't look very different. There was a yellow-green
weighing machine outside chained to the wall and the
window display didn't look like it had been changed
in years. The glass was lined with yellow cellophane
to prevent the goods from fading in the sunlight.
Shops don't seem to do that anymore.

I went inside, a bell rang as I opened the door.
There was no-one behind the counter so I was able to
have a good look round. The smell was the first
thing that hit me, it hadn't changed at all. A sort
of medicine and yeast smell. Apart from all the
medicines and cosmetics there were things I'd
forgotten about, tins of pastilles, glucose sweets
and barley sugar twists. My mum would sometimes
bring them home with her because for a while she
worked there on Wednesday afternoons, tidying all
the bottles and jars in the back where Mr. Brumfit
made up the prescriptions.

After a minute, a woman came out to serve me. I x
asked if she could process my film and she said she
could but she'd have to send it away so it might
take up to a week. That's more like it. I explained
that it was very old film and that there might not
be anything XXXX on it. She said they'd do their
best and would I like them to make a print of
anything on the negative? I thought, well why not?
You can't see much from a negative.

. I somehow lost all sense of time walking back ~~XXXXXX~~
through my old neighbourhood because I stopped
at a shop and bought two more scotch eggs and a
jar of beetroot. It wasn't until I got home that
I realised I'd already had my lunch.

I wonder what the picture will be of. 1960. I'd
have been seven years old.
Shouldn't get my hopes up. Other people's photo-
graphs are extremely dull. Especially the man
from Wooton Green's, I imagine. This is because
the difference between a snapshot and a picture
is that one is of interest only to ourselves and
the other serves to recreate in others the feeling
or sensation we had when we took it. In other words
the snapshot is personal, the picture universal.
(Professor Steinhauer)

On the other hand, Mr Wooton Green may not have
taken the picture. The Rolleiflex is after all
more a camera for the serious professional or
conscientious amateur. It could have belonged to
someone else before him and that person might
easily have specialised in advertising promotion,
news journalism or artistic nude studies. I'll
give Brumfit's a ring tomorrow. See how ~~XXXXX~~
they're doing.

Tuesday November 29,

Well well. A very swift response from Box 107.
I only dropped my postcard in to the Gazette
yesterday. Someone's keen, though it seems like
I'm up against stiff competition. How am I
expected to know what's in the package? No clue
in the picture on the card as far as I can make
out. Very intriguing. I'll ring after 6.00 to
see if I can find out what their game is.

GREETINGS

THIS IS A REAL PHOTOGRAPH

BECKMANN VOSS Fine Printing. England.

Dear Mr. Whittingham,
Thank you for your
letter. Could you please
telephone and describe
the contents of your
package as I have
another gentleman
with a similar claim.
Phone 647310 (evenings)

TARN CAUSEWAY, FOREDHAM.

Mr. M. Whittingham
67 Warmander Avenue
Whetford
Worcs.

Got up. Had breakfast, poached egg on
toast. Loaded new film into my camera.
This is the film Mr Middleman gave me
yesterday free of charge to 'start me XXX
off' which was extremely generous of him.
He made me promise to let him know how I
got on and of course if I needed anything
else in the way of photographic equipment,
he'd be only too happy to help.

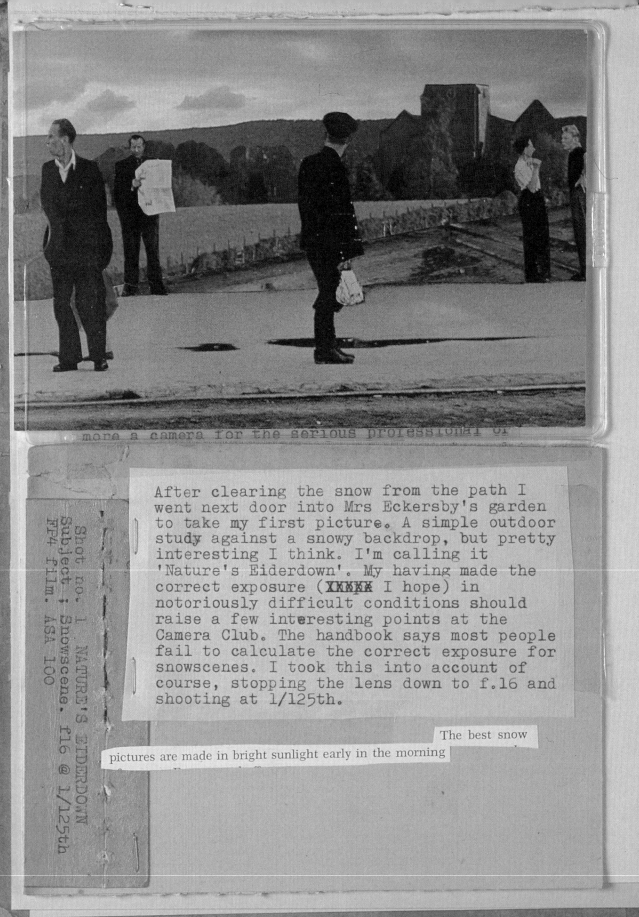

more a camera for the serious professional or

After clearing the snow from the path I
went next door into Mrs Eckersby's garden
to take my first picture. A simple outdoor
study against a snowy backdrop, but pretty
interesting I think. I'm calling it
'Nature's Eiderdown'. My having made the
correct exposure (XXXXX I hope) in
notoriously difficult conditions should
raise a few interesting points at the
Camera Club. The handbook says most people
fail to calculate the correct exposure for
snowscenes. I took this into account of
course, stopping the lens down to f.16 and
shooting at 1/125th.

The best snow
pictures are made in bright sunlight early in the morning

Shot no. 1. NATURE'S EIDERDOWN
Subject ; Snowscene. F16 @ 1/125th
FP4 film. ASA 100

Had to go to Crossley to pick up my shoes from the
menders so while I was there popped into Middleman's
Photographic and told him about my first picture.
Asked if he thought f16 @ 1/125th sounded about
right to him for a snow scene. He tried to sell
me a light meter but I told him I didn't think Xx
that would be necessary since the Rollei already
has a perfectly good built-in light meter. He said
Brumfit's could always over- or under-expose when
printing to compensate for any error. I told him
I didn't think that would be XXXXXX necessary
either. I think he was rather impressed.

Well then we got onto night exposure and I was X
posing one or two interesting points on that sub-
ject when he suddenly remembered something he had
to take care of in the stockroom. Apparently
Tuesday is his busiest day. I wanted to show him
how I'd managed to replace the broken strap on my
camera with an old belt that I cut down last
night with my Stanley knife. Never mind, I can
show it to him next time I pop in.

There's a narrow alleyway that runs down the side
of Middleman's. I was just on my way to the bus
stop when I noticed a cardboard box of magazines
and newspapers next to the dustbins. There was an
old copy of Amateur Photography on top. I
couldn't imagine they were being thrown out,
perhaps they'd been put there for someone to X
collect. I had a quick root through. For a moment
I thought I saw Mr Middleman watching me from the
side window but when I looked up, he'd gone.
Nobody else was looking so I picked up the box
and made off with it. Well, why not? It's not
stealing. If they didn't want anyone to take them,
they shouldn't put them by the dustbins.

'LOOK WHAT THE HOUND FOUND!'
Temporarily removed for Camera
Club meeting, Friday December 2nd.

Same day. 5.25 p.m.

Went through the magazines. Some very
interesting stuff. Mostly from the late
1950s. A couple of 'Amateur Photography's
with hints on home portraiture. Other
titles from that period. 'Picture Post',
'Illustrated', that sort of thing. Some
of the old advertisments are most amusing.
How times have changed. Also a few news-
papers. Found several good pictures which
I have cut XXXX out. Most are XX black
and white which I think is better because
Alistair seems to favour that type over
colour. More artistic. My favourite is
the one of the dog playing the drums
(promotional picture for The Melody Parade
music shop) called 'Look What the Hound
Found!' - Excellent title. I expect the
others in the class will turn up with
colour shots culled from back issues of
Camera Weekly and I don't think that's
what Alistair is after at all.

There's all kinds of stuff in the box.
Knitting patterns; envelopes. Quite a bit
of paper and card that hasn't been written
on which I shall make good use of. I even
found an old XXXX football coupon. It had
been filled in but hadn't been sent off.
Who knows? It might have hit the jackpot.
There are quite a few magazines still to
go through. I'll look at them later.

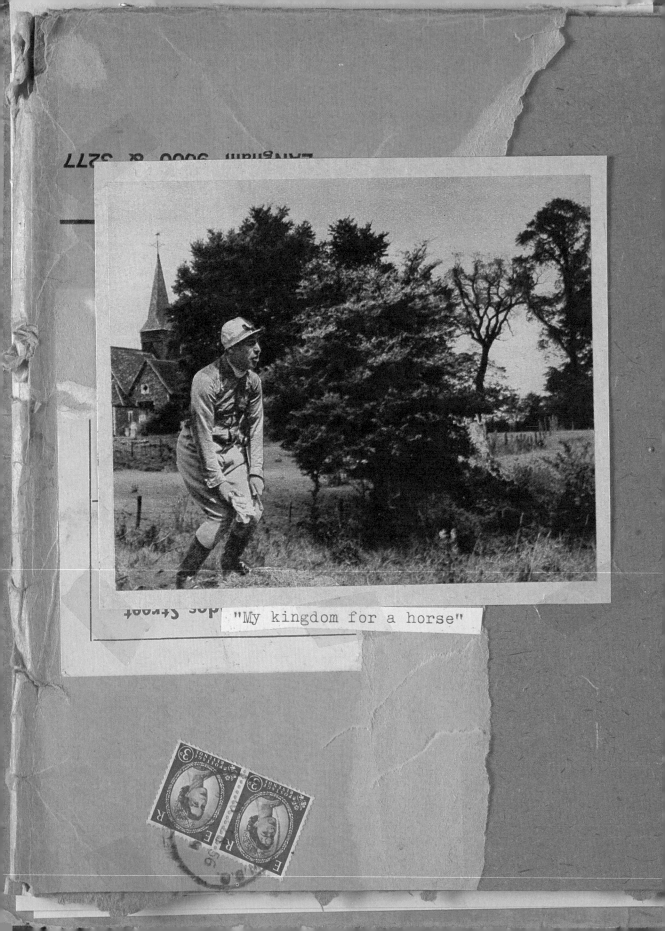

"My kingdom for a horse"

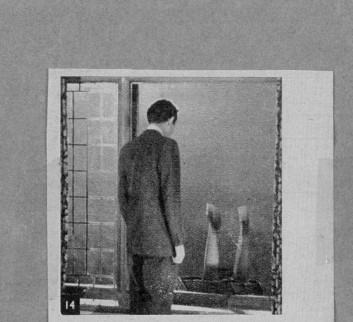

14

AND THIS IS THE END FOR THE UPTURNED LADY

Name The Perfect Solution ...

...

Re-order No. 25.

THREE POINT LANDING

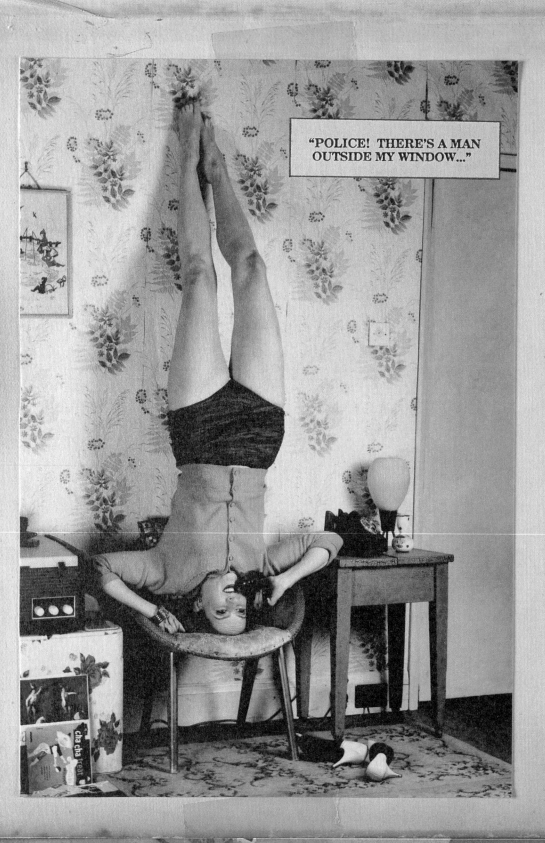

Phoned Box 107. A woman answered. Conversation recorded at 6.10 p.m.

Yes can I help you?

It's Mr. Whittingham about the package I left on the bus.

Oh, yes Mr. Whittingham. Well as I said, a gentleman has already come forward to claim it so it's possible it wasn't your package I found. Would you mind telling me what was inside?

Inside my package?

Yes.

You opened it then?

Yes, to see what was inside.

And what was inside?

Well you tell me.

Um. I think there were some pictures.

What kind of pictures?

Pictures of a - shall we say - lewd nature.

Well it's clearly not your package then. This one contains a shirt from Marks and Spencers. Goodbye.

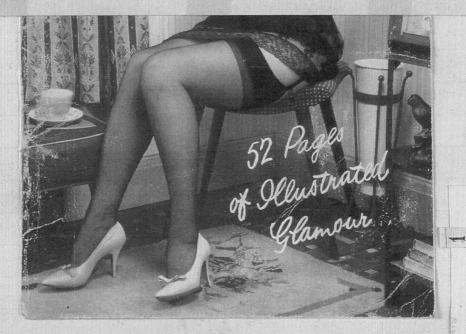

52 Pages of Illustrated Glamour

Stupid woman. Leading people on a wild goose chase. If I'd guessed right I could have got myself a new shirt. I could do with a new shirt and Marks and Spencers is very good quality.

Since the police interview I record all my conversations (and take carbons of my letters.) I suppose that's what got me onto the Camera Club really. Them saying I should get out more, meet new people. Well what do they know? I meet people all the time. But photography interests me so I joined anyway. It's no good telling the police the suggestive things some of the people say when you ring about their adverts. If only I8d recorded some of those conversations, they'd <u>have</u> to believe me. Well I'm not getting caught out again.
Read Woman's Own (July 1958). Went to bed.

Wednesday 30 NOVEMBER,

I had a bit of a lie in, reading the handbook's chapter on the optical defects of lenses. I could hear Mrs. Eckersby again through the wall talking to that man. There was a van parked outside yesterday. I wonder what they're up to.

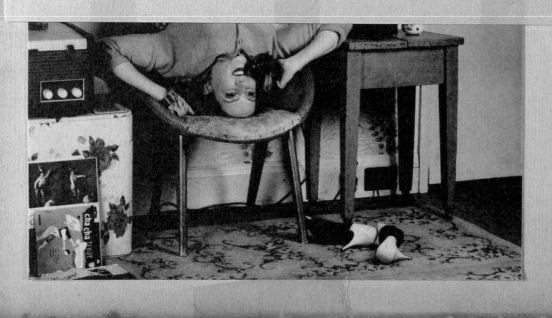

After breakfast and washing my plate I made a
very interesting discovery concerning Mr.
Middleman's reading habits. In amongst the pile
of magazines was a copy of 'Bravado', a magazine
for 'artists and photographers interested in
the natural grace and beauty of the naked female
form'. It contains 'glamour' shots of scantily-
clad women posing in what looks like their XXX

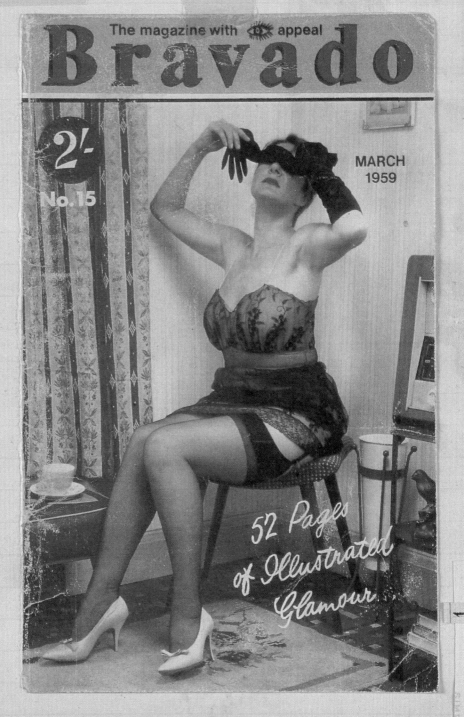

The magazine with 👁👁 appeal

Bravado

2/-

No. 15

MARCH
1959

*52 Pages
of Illustrated
Glamour*

own homes. Quite tame by today's standards but
pretty risqué for the time I imagine. Some of the
women in the pictures are covering their faces.
I assume this is because they were doing it to make
a few extra pounds to help with the housekeeping
while their husbands were out at work and didn't
want anyone to know about it. You can tell by the
backgrounds that these were just ordinary women,
not glamour starlets or showgirls.

Each picture is accompanied by technical data
about what camera and aperture was used for the
shot 'as an aid to the budding photographer', but
it's clearly just an excuse to show women in their
underwear.

It seems Mr. Middleman is a bit of a dark horse.
Or at least he was in those days. I've never heard
of Bravado before but I do remember similar
publications being discovered behind the scout hut
by Nicholas Morris. Fishnet stockings and black
bras. (The women in the magazines, not Nicholas
Morris.) My mother said that black bras were only
worn by those 'common' women who dyed their hair
and worked at fairgrounds.

Disgusting, she said. Like the Mr. Rose incident
when I was little. Mr. Rose, our butcher, was a
bit of a cheeky chappie with an eye for the ladies.
Always winking at the young mothers. I'd often go
in the shop with my mum. He'd be all wet lips and
red in the face like a chump chop, wrapping things
up in paper and licking the end of his pencil.

"Here y'are, Joyce. Take this home to your old
man." That kind of thing.

My mum went along with it even though she hated
'the crude type.'

One time he said, "Hold on, sweetheart, I've got
something that'll interest you." Normally it was
a bit of stewing steak or something but on this
occasion he got his 'lad' to fetch a magazine from
out the back which Mr. Rose held open in front of

us. It was a picture of a woman showing her bosoms. My mum went very red and we left the shop in a hurry. Mr. Rose and his lad were laughing.

Interestingly enough, the photographic data states that Bravado's cover picture was taken with a Rolleiflex set to f.8 @ 1/50th using Agfacolour film. I'll have to get some Agfacolour. In fact several of the women have been snapped with a Rolleiflex which just goes to prove Dr Steinhauer's point (Chapter 3 - Choosing the Right Camera) that the Rollei is as at home in the professional photographic studio as it is outdoors on a family picnic.

There are some very intriguing adverts in the back. I suppose they had to be pretty cagey about what they were actually selling. If only I could reply to some of these.

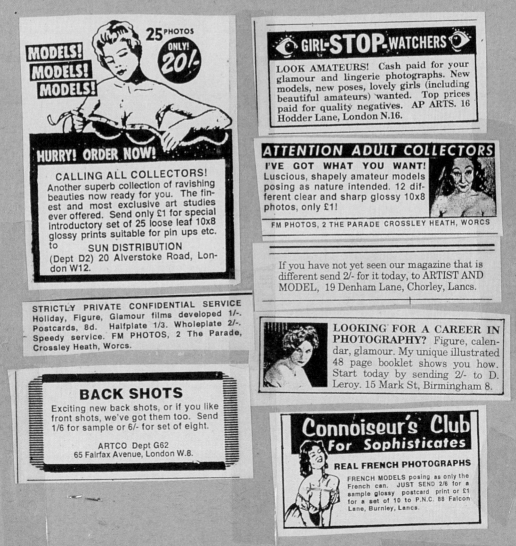

Read the chapter on depth of focus before
setting off for Brumfit's wearing my newly
repaired shoes. Bit stiff at present but I'm
sure they'll soften up. I decided to take my
film in to be developed. There's only one
shot on it (Nature's Eiderdown) which is a
bit of a waste - I was planning to do a whole
series on the 'Winter Wonderland' theme but
yesterday's snow melted. At least it will be
ready for week 3 at the Camera Club.

When I put my coat on to go out I found the
doll in my pocket which I had forgotten about.
Put her on the coffee table.

Same strange quietness about the neighbourhood.
Nobody out XX on the streets. The only people
I saw were in the garden of the corner house.
A woman and a young boy were standing on the
lawn looking XXXXXX all around them as though
searching for something. I crossed to the
other side of the road and tried not to look
at them.

Handed my film in at Brumfit's and bought a
barley sugar twist. When I was little we used
to peel the wrapper halfway down and then
suck one end into a point. It took ages but
you could get a really sharp point on it. One
day Timothy Abrahams was holding his sharpened
stick of barley sugar in his mouth when he
fell over in the playground and stabbed
himself in the throat. Someone said that the
point came out through the back of his neck
but I'm not sure if that's XXX true. We all
stopped after that.

(Some other things found amongst the magazines in the box)

(Is it a raffle ticket?)

16 16

I hadn't expected my enlargement from the 1960 film to be
ready yet but as I was leaving, the woman handed me a stiff
brown envelope. Apparently the lab suspected that over the
years light had leaked into the camera and fogged the film.
They'd made the best print from the negative that they could.

I was so excited about my photographic enlargement. I wanted
to choose the perfect moment. No peeping on the way home.

I was a few minutes from the house when it began to snow
again. Big white fluffy flakes falling silently from the sky.
A car radio across the street was playing 'Silent Night' and
I suddenly felt rather Christmassy. It's a bit early, I know,
but you can't plan these feelings.

When I got inside, I dug out my cassette of XXXXXXX Christmas
music (Boys Choir from Coventry Cathedral) and put both bars
of the electric fire on. Poured myself a sherry, (well why
not?) put on my slippers and settled down xx with my package.
And as I removed the photograph from its envelope I was
confronted by this vision.

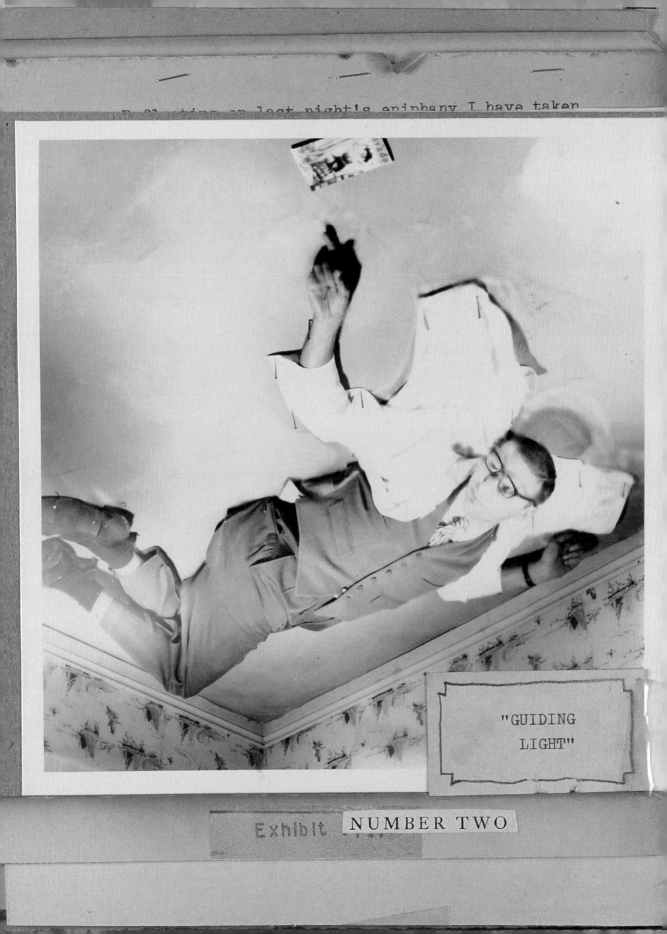

"GUIDING
LIGHT"

Exhibit NUMBER TWO

For some time I stared at the strangely
illuminated figure wondering who or what it
could be. And then the voices on the cassette
player provided me with my answer. "The angel
of the lord came down and glory shone around."
Yes. Came down. And shone glory onto someone's
humble dwelling.

But who had managed to capture this celestial
being on film? I've never been a religious
man but even a novice couldn't fail to see the
difficulty in calculating the exposure for a
heavenly vision. The Weston Master 6 light
meter would be virtually useless in such a
situation.

I sat staring at the picture until the choir
stopped singing and my eyes could focus no
longer. I placed the picture in my diary and
closed the book lest the picture's luminescent
energy should escape, and sat down at the
window with another sherry to recover. It had
stopped snowing. For the longest time I
stared deep into the heavenly sky offering
thanks to the celestial gods for sending me
their divine messenger. And for the first time
since I was a boy, the tears welled up in my
eyes and I began to cry.

Thursday 1 DECEMBER,

I don't remember much of what happened last
night after that. I woke this morning to find
myself lying fully dressed in front of the
fire. I was very hot and I had a headache.
When I stood up I felt a stinging sensation in
my knees. Pulling up my trouser leg to
investigate, I found my legs were very red and
there was a large water blister on each kneecap.
Near to where I'd been laying there were two
macaroons on a saucer.

Reflecting on last night's epiphany I have taken
another look at the photograph, and in the clear
light░░ of day certain details emerge. Judging by
the background, it all seems to have happened in
someone's home. But who's home? The man in Wooton
Green I suppose, though nothing looks familiar.
Then again, this is a long time ago.

The vision must have had ░░░░░░░░░ a
profound effect on the photographer.
Perhaps he was so spiritually moved
by the event that afterwards he
abandoned the camera altogether never
to click the shutter again. But why
didn't he have the film developed?

And why wait until now, more than 30 years later
to sell the camera? I'll have to ask him about it.

I was just about to telephone him when it suddenly
occurred to me that the figure is pointing at
something on the ceiling. And though much of the
detail is lost, I can ░░░░░░░░░░░░░░ just make out
the letters v..a..d..o. I'm sure this is a copy of
Bravado. The same issue, if I'm not mistaken as
the one I found in the box left outside Middleman's.
No. 15, March 1959. Which tallies with the date on
the undeveloped film. This must be a sign. Anything
else would be just too much of a coincidence. I've
titled the picture 'Guiding Light' because I feel
sure this heavenly vision is pointing me towards
the truth. But if this is one of God's winged
messengers, then what is the message? And who is
the message for? Me, or the man from Wooton Green? Me.

After lunch (Welsh Rarebit, which I cooked myself)
I looked through Bravado again, hoping to find some
clue, something significant within the magazine
that I had overlooked. And I did.

The head of one of the women in the pictures has
been torn off. Seems like a strange thing to do.
I checked the other side of the page to see if
there was anything of note on the back but it's
just writing. It seems to have been torn
deliberately. Must have been Mr. Middleman, but
why would he do that? I've taken it out of the
magazine so that I may study it more carefully.

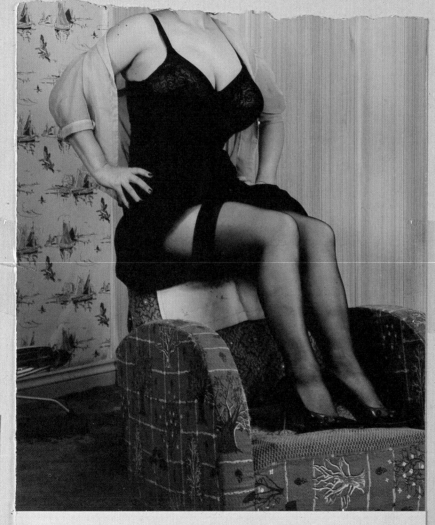

No. 8 Beauty Unadorned

1/5th at F.5.6 on Ilford FP3 film. Diffused daylight, one open flood as fill
in. Rolleiflex.

I had planned to do my ironing this afternoon but
I became so intrigued to know who this woman was
that I started looking through the rest of the
magazine to see if there were any more pictures
of her, taking clues from body shape, clothing
and decor. After careful study I concluded that
this was the only picture of her. XXXXXXXXXXXXX
She's certainly quite full-figured and although
the buxom type seems to have been very much in
vogue then, none of the other models quite match
her proportions. Besides, our headless beauty
also has a triangle of freckles on her right
shoulder which I can't see on any of the other
women. From the background it looks like a fairly
typical suburban home. I wonder what her story
was. I can't ask Mr. Middleman about it or he'll
know it was me who took the magazines.

greedy spell for a no feet of air.

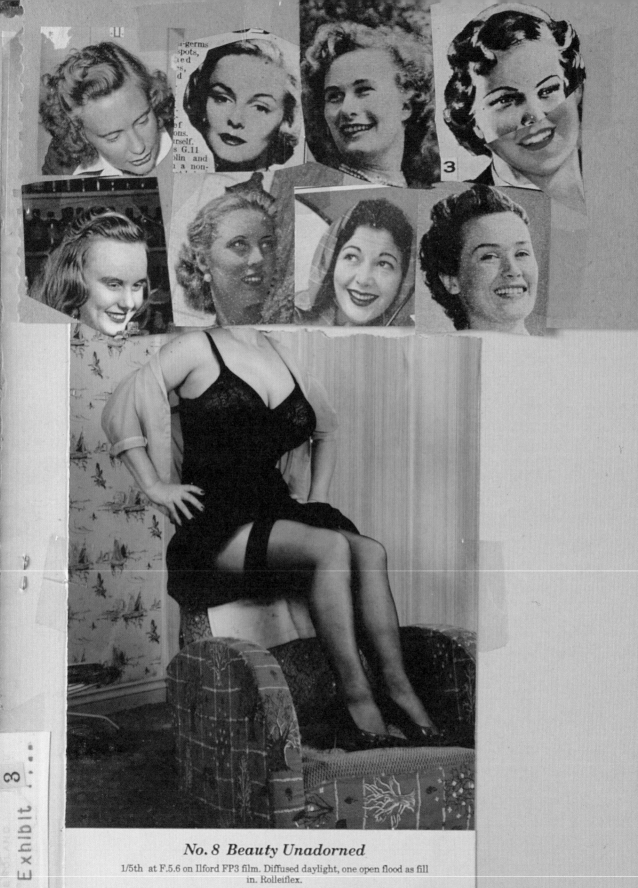

No. 8 Beauty Unadorned
1/5th at F.5.6 on Ilford FP3 film. Diffused daylight, one open flood as fill in. Rolleiflex.

I was wondering what kind of face this 'Beauty Unadorned' would have had and to help me visualise it I started cutting out faces from the other magazines and holding them in place to see which type fits best. Didn't really work. None of them seemed quite right. Went to bed with a glass of milk and a cream cracker.

Searched the box and the rest of the magazines
thinking the torn head might have slipped
between their pages, but no luck. I can't find
anything else in there that seems significant.
There's this but I'm not sure what it is.
Could the angel be sending me another clue?
Gold Tips, what's that? Sounds like a brand of
tea. And what does WHE mean? Could they be the
initials of the previous owner of the magazines?
(If they're not Middleman's.)

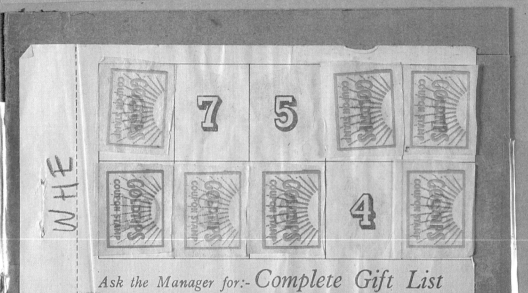

Ask the Manager for:- Complete Gift List

Exhibit 4

And if the man from Wooton Green did take the
'Guiding Light' picture, then perhaps he knows
something about Bravado and the torn head.

Rang him several times but there was no reply.

Scanned the pages of <u>Bravado</u> again for further clues to help me identify 'Beauty Unadorned' but there's nothing. A page which might have been a subscription order form or something has been cut out leaving the pink stub still stapled in with the rest of the magazine, but that doesn't tell me anything.

After lunch (two Fray Bentos steak and kidney pies) read Chapter 14 'Building your own Darkroom'. Could be a sound investment. I'd save all that money on enlargements and I'd get them back straight away. Much more control over my finished print too. (Of course it would mean having to buy all the equipment first which could be expensive.)

Do You Need a Darkroom

No, you don't absolutely *need* a darkroom, but Paul Farber's words bear repeating: *"Anyone who uses a camera but does not have a darkroom is depriving himself of half the fun of photography. It's a little like owning the leash without the puppy."*

I suppose it's an extravagence with me not having a job just now but I still have £3,580 of my savings left. I'll pop into Middleman's when I'm next in Crossley. Perhaps I can make some income from selling my photographs. Dr. Steinhauer has a whole chapter on that, with some useful advice on how to go about it.

First Thoughts on Profitable Photography

FREE ! POST THIS COUPON NOW

I think Mrs. Eckersby might be blind. I see her out in the garden sometimes, smelling the roses. She looks blind to me.

THE BRAVADO
Beauty Parade
COMPETITION

THIS monthly contest is designed purely for the benefit of the amateur photographer who would like a chance to gain experience and the opportunity to see his work published. The contest is based on the principle of allowing the readers of BRAVADO to judge the winner for themselves. Ten full-page photographs are featured in each month's beauty parade and it is merely a matter of picking out your own particular favourite. Then record your choice on the pink pre-paid postcard enclosed and slip it into the nearest pillar box. The cards are counted as they arrive at our office and the competitor who receives the most votes is the winner. It's as simple as that. And remember, there is no need to pay any postage - we deal with that at our end.

HOW TO ENTER

GENTLEMEN! This is your opportunity. If you'd like to enter this contest, just send one or more photographs along with the completed entry form at the back of the magazine. If possible, photographs submitted should not be smaller than 5in x 4in. Hard, contrasty glossy prints are by far the best for reproduction purposes and it will greatly enhance your chances if you bear this in mind when submitting pictures. All pictures sent in receive the most careful consideration and, while we cannot promise to publish every one, we will not reject any lightly.

And now gentlemen, it's up to you!

Winners of the February Contest

1st C.N. Carpenter
2nd B. Hatton
3rd D.W. Brockhurst

I wonder if any of these models
is 'Beauty Unadorned', the
mystery woman with the missing
head. This advert from the classified section of
a 1959 Whetford and Crossley Gazette is obviously
from a long time ago but it's possible the place
might still exist. It's worth a try.

It was only when I started trying to work out
which numbers represent the old exchange WHEtford
that I suddenly remembered the letters WHE on the
Gold Tips coupon card, and when I checked it found
the numbers left uncovered by the stamps are the
same as the Studio Arts Club telephone number.
Coincidence? I don't think so. I picked up the
phone and XXXXXX dialled. A woman answered.

Hello, Brumfit's.

(Brumfit's?)

Hello, can I help you?

Is that Brumfit's the Chemists?

Yes.

The Chemist's on St. Alban's Road?

Yes. Can I help you?

1	---
2	ABC
3	DEF
4	GHI
5	JKL
6	MN
7	PRS
8	TUV
9	WXY
0	OQ

(How had I got through to Brumfit's? For a while
I couldn't understand what had happened.)

Er. Yes, I was just calling to see if my
film was ready yet.

(I knew it wouldn't be. I only took it in on
Wednesday.)

Colour or black and white?

Black and white. 120mm film.

And the name?

Whittingham.

One moment please.

(Pause)

Yes. It's just come in,
Mr. Whittingham.

Splendid. I'll come and
collect it later on.

Conversation recorded at 1.55 p.m.

Well, well, well. I suppose this could be a XXXXXX
coincidence, but if Brumfit's Pharmacy has kept
the same telephone number since 1959 as I suspect
they have, then it means that the Studio Arts Club
must have been held in the studio above the shop.
And that old Mr. Brumfit decided to branch out
from normal passport portraits into the world of
commercial glamour photography. I wonder who else
knew about this. My mother didn't, that's for
sure. She'd have had a fit.

It all makes sense though. He'd have the facil-
ities with his studio, and if, as I imagine, he
did his own film processing he would be able to
offer a discreet service to the semi-professional
or seasoned amateur that turned a blind eye to
the lewd nature of the subject matter. And to
think XXX all this was going on in our
neighbourhood...

On the bus to Crossley I was surprised to note
how quiet it was. It's true you never see many
people until you get past the library but we were
already at the big roundabout and I was only on
number seven (ugly woman with poodle.) Normally
I've had sex with at least two by then. Must be a
bank holiday or something. This of course made
it impossible for my cake-shop beauty to be
number ten which is a shame because she looked
particularly lovely today. XXXXXXXXXX(Her name
is Doreen Collar. I went into the shop and asked
the other day when she wasn't there.)

Mr. Middleman (his XXX name is Frank, he gave me
his card) seemed delighted to see me again
especially when I told him of my plans to build
a darkroom. A rather costly enterprise as it
turns out but I feel as a serious amateur, or who
knows maybe even a XXXXXXXXXXXXX semi-
professional, it's something I'm going to need.
Frank says that in six months it will have paid
for itself so it's an investment really.

The whole kit comprises of:

Enlarger Drying clips
Developer Masking frame
Fix Thermometer
Developing tank Interval timer
Squeegee Safe light
Tongs Photographic paper
Stop bath Developing tank
Plastic measure

(Also bought film.) It's a lot of my savings gone
but I should be all right. Now I ▨▨ can process
my own film and do my own printing. Frank said he'd
have all the stuff delivered in the morning. I
can't wait. By tomorrow night I could be admiring
my own enlargements.

FIXING BATH · STOP BATH · DEVELOPER

I wanted to go home and make a
start on the darkroom but I
thought I'd better collect
'Nature's Eiderdown' from
Brumfit's. I need something for
the Camera Club meeting tonight.
I'd almost forgotten about it
with all the excitement of the
past few days.

Do I need an apron?

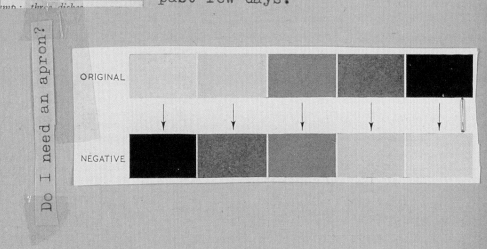

ORIGINAL

NEGATIVE

You're in luck Mr. Whittingham. Yours has just come back.

Come back? Oh I thought you did the printing here.

No, we send it out. All our films go over to Middleman's in Crossley.

I didn't know Middleman's did film processing.

Oh yes. We've been using them for donkey's years. They're very good.

Why would Mr. Middleman say they don't do processing when they do? Sending me all the way over to Brumfit's so that they can send my film back to him? Probably worried that someone who knows the ins and outs of photography I'm in a better position to stand in judgement of his darkroom prowess.

As I was paying for my print, I asked the woman about the photographic studio.

What here? No.

I understood there was a small photographic studio above the shop. Passport photos, baby pictures, that sort of thing.

No, dear. Nothing like that.

Really? There used to be. When Mr. Brumfit was here.

Ooh, that's a long time ago. The studio closed down after Mr. Brumfit died.

When was that?

A long time ago. In the fifties it must have been.

He was still alive in 1959 because that's the year Mum died and she was working there then. I'd

(Conversation recorded 4.41 p.m.)

sometimes call in on my way home from school.
Mr Brumfit was a giant of a man in a white
coat who looked too big for the place. He was
always nice to me. Whenever I went in he'd
wink and give me a peppermint.

Nobody used that room much after what happened.

Why, what happened?

I'd rather not talk about it, if you don't mind.
That's all over with now. It's all gone.

What's gone? The studio?

If you're looking for a photo studio, there's a
young chap on Rookery Road who does that sort of
thing.

Yes, I bet there is.

I caught the 16 from St Alban's Road where my
counting became hampered by the sudden appear-
ance of a coach party of women at the crucial
moment. Couldn't count quick enough – crowds
are always difficult – so I missed having
any of them.

Same day. 5.20 p.m.

I'm back at home now with a Ginster's cornish
pasty warming in the oven. Very puzzling, all
that about Brumfit's studio. I wonder why she
didn't want to talk about it.

'Nature's Eiderdown' came out rather well,
bearing in mind the inherent difficulty of
exposing correctly in such a situation. One
wants to expose for the shadows of course with-
out losing detail in the subject. The big
mistake people tend to make is to underexpose
because of the brightness of the snow when in
fact it is necessary to overexpose. I can't
imagine anyone at the Camera Club will know
that. It'll be something Alistair and I can
share with the others tonight.

 If you can't build a darkroom of your own, improvise. Bathrooms
and kitchens have been happily pressed into service as temporary dark-
rooms. The only problems are: 1. securing the *dark*, and 2. working out
an arrangement with wife or mother. Keep things spotless, avoid con-
taminating the room, and no one can have any serious objections.

Spent the rest of the
afternoon converting
the bathroom into a
darkroom ready for
when the equipment
arrives tomorrow.
I had first considered the loft but when I took a look up there
I realised there isn't much headroom for someone my size and I
wouldn't be able to do much kneeling until my blisters go down.
They're still very sore, my knees. Did I mention I got some
ointment from the chemist?

Hung an old velvet curtain over the door and painted the window
panes with blackboard paint. At first this seemed to do the
trick but the longer I spent in there, the more my eyes grew
accustomed to the darkness until I could see light leaking in
all over the place. In the end I had to stick a layer of wall-
paper over each window and give the whole thing an extra two
coats of paint. Took the kitchen door off (very heavy) and laid
it across the bath which will provide a pretty solid platform
for my enlarger. xxxxx I have run an extension lead under the
door ready for the enlarger and safe light. Bit dangerous I
suppose but what else can I do? Cut a length of garden hose
to run off the sink taps for washing prints.

With all that done, I got ready for the meeting. (Beige corduroy
slacks and slate blue knitted shirt with inset collar and
contrasting trim.)

Darkroom: Here the Magic Begins

"NATURE'S EIDERDOWN"

Same day. 9.55 p.m.

Very good meeting, though rather poor turnout.
Only eight in attendance this week.

Alistair chose my picture (among others) to
pin on the wall for discussion. Unfortunately
he hung it upside-down like this, thinking it
was of a bird instead of Mrs. Eckersby's cat.
He congratulated me on handling potentially
tricky lighting conditions so I didn't say
anything.

Darkroom: Here the Magic Begins

If you can't build a darkroom of your own, the usual bathroom and kitchens have been simply pressed into service as temporary darkrooms. The only nuisance is securing the *dark*, and if a photographer is an arrangement with his or her mother. Keep things spotless. Avoid with a lamp will ... no one can have any serious objections.

my kne
st?

in over
nt. At
ent ir
unt
en

"NATURE'S EIDERDOWN"

Same day. 9.55 p.m.

Very good meeting, though rather poor turnout.
Only eight in attendance this week.

Alistair chose my picture (among others) to
pin on the wall for discussion. Unfortunately
he hung it upside-down like this, thinking it
was of a bird instead of Mrs. Eckersby's cat.
He congratulated me on handling potentially
tricky lighting conditions so I didn't say
anything.

Darkroom: Here the Magic Begins

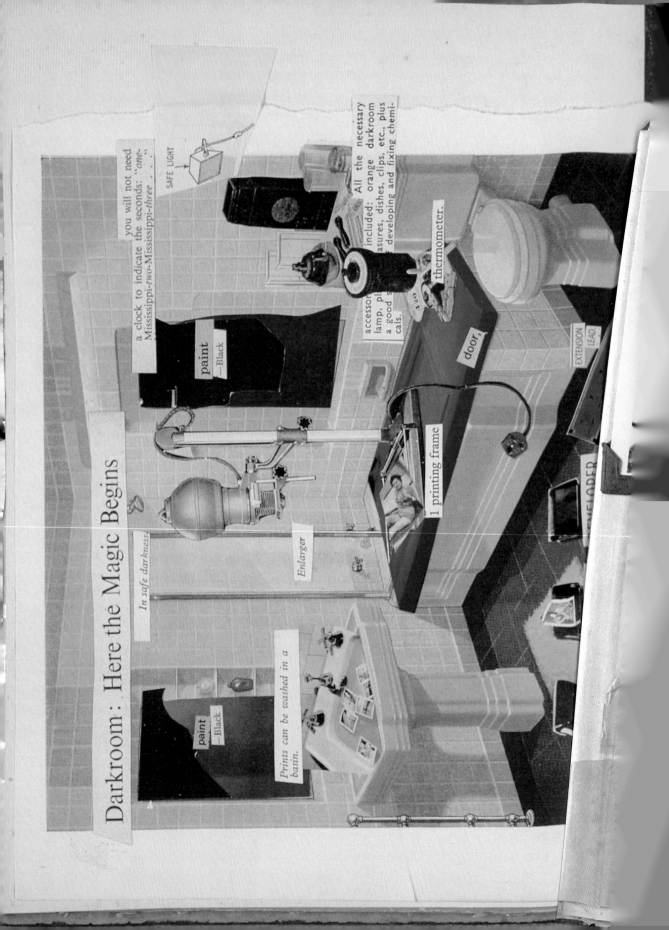

SAFE LIGHT

... you will not need a clock to indicate the seconds: "one-Mississippi-*two*-Mississippi-*three* ...".

All the necessary accessories are included: orange darkroom lamp, plus measures, dishes, clips, etc., plus a good selection of developing and fixing chemicals.

thermometer.

paint —Black

door,

EXTENSION LEAD

1 printing frame

Enlarger

In safe darkness

ENLARGER

paint —Black

Prints can be washed in a basin.

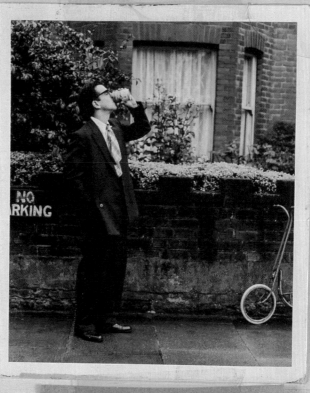

'Pause for Refreshment'

I don't know who took the picture or why, probably
it was my mum, but until seeing it again I'd
forgotten about Dad's predilection for evaporated
milk. I remember having it at home a lot with
tinned pears or strawberries (Dad's favourite)
but presumably this was not enough to satiate his
need as I would often come home from school to
find him standing outside St. Alban's Road shops,
head back with a sixpenny tin to his lips. He
would even take his own opener, a metal tool that
punctured two triangular holes in the top. He
always looked guilty when he saw me as if I had
caught him doing something he shouldn't.

There's a negative for the party picture ('Balloon
Buffoonery' as I've titled it) but it's colour.
Print quality is greatly reduced when using a
colour negative to make a black and white print.
Loaded a new film in my camera. Must choose an
assignment. I need to get snapping so that I've
got something to print.

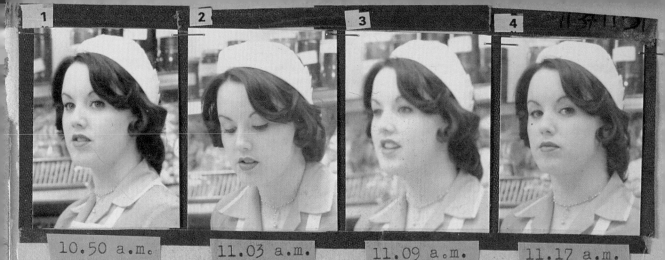

| 10.50 a.m. | 11.03 a.m. | 11.09 a.m. | 11.17 a.m. |

The great thing about a Rolleiflex (or any twin
lens reflex) is that you don't have to hold it up
to your eye to take a photograph. With the camera
at waist level no-one can see what you're up to.

I stood outside Patterson's Patisserie for a good
part of the morning pretending to read a paperback
novel I'd bought in the market for 10p. XXXXX
('Lens Lust' - the amourous adventures of a
luscious model on her way to success.) Once I'd
set the focus I could snap away without arousing
suspicion. It made me nervous to be in such close
proximity with my lovely. Of course I've walked
past the shop on numerous occasions. Glanced in,
but never had time to really study her.

She stood there, the outside lights illumining her
perfect 34-22-34 figure. Johnny was amazed at the
precise symmetry, the rounded perfection. This was
what he had wanted for so long. This was the girl
who had gotten under his skin, taunted him, teased
him. And now she was all his...all his to enjoy as
he wished.

— 136 —

Now I've captured
Miss Doreen
Collar on film
and I can study
her at my leisure.
I was a XXX bit
worried about
reflections on
the glass and the
poor lighting
conditions but having printed up the best of the
bunch I am quite pleased. My favourite is no. 4
(11.17 a.m.) where she is looking directly at me,
having been alerted to my presence outside the
shop by one of the other assistants.

I must confess I've often wondered what this whole-
some creature would look like in her underwear. In
the morning perhaps, when she's getting ready for
work. Admiring herself in the mirror possibly,

applying lipstick before putting on her uniform.
Or at night when she gets home, exhausted from a
~~day of dishing out the rum babas and finger~~

10

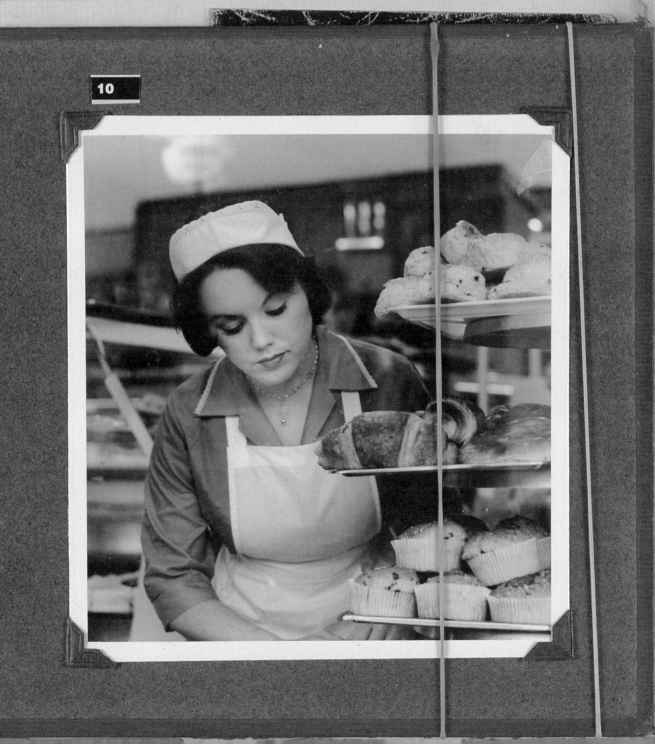

The biggest problem is finding a suitabl
model. I don't know of any model agenc
that will find one for you. It is usually u
to the photographer himself to inquir
around and locate a girl willing to pose
The younger the girl you choose, the sure
you are to have a girl with a good figure
but a girl of 18 or 19 is just about idea

By taking at least twelve pictures in various poses and
angles, I can then decide what to do and what not
to do the day we work together. That's how I dis-
cover her good angles.

PALE GREEN.

there was a police picture taken at the scene of

applying lipstick before putting on her uniform.
Or at night when she gets home, exhausted from a
day of dishing out the rum babas and finger

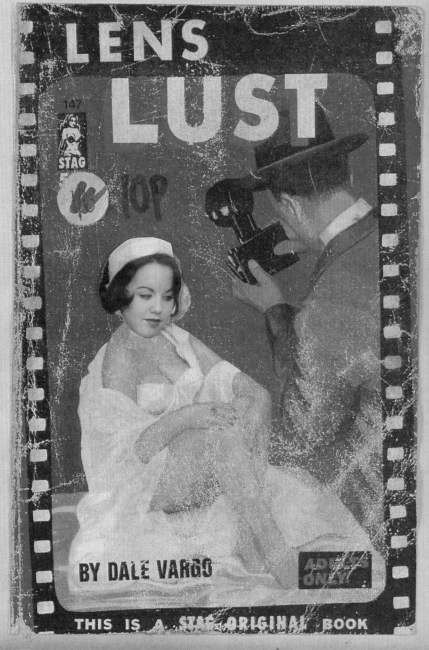

LENS
LUST

147

STAG

Stop

BY DALE VARGO

ADULTS
ONLY

THIS IS A STAG ORIGINAL BOOK

declined saying she had another appointment.

Making copies of existing photographs turns out to be relatively easy. Having read the relevant chapter in the handbook I took 'Beauty Unadorned' out into the garden and have subsequently maid a fairly decent copy of it ~~XX~~ in my darkroom.

applying lipstick before putting on her uniform.
Or at night when she gets home, exhausted from a
day of dishing out the rum babas and finger
fancies, relaxing in an easy chair or reclining
shamelessly on her bed. With a fur bedspread
probably.

I need to focus my thoughts on my investigation.
I should remind myself that the purpose of this
exercise is to see what 'Beauty Unadorned' would
look like with a head, not how my cheesecake
charmer might look in her underwear. --Which
raises an interesting point I think. Am I
sticking heads onto bodies or bodies onto heads?
And could whoever tore off part of the pin-up
picture - Mr. Middleman for example - have done
so because he wanted to keep the head, not throw
it away? Perhaps 'Beauty Unadorned' had a very
pretty face and her body was not to his taste.
Who knows what goes on in other people's minds?

Monday 5

Weather sunny. Bought a bag of broken biscuits
from Binson's. At the factory they put all their
broken biscuits into big bags which you can buy
for a pound. They're not all plain either. Quite
a lot of chocolate ones and Jammy Dodgers which
are my favourites. (They're not real Jammy
Dodgers, they're Binson's own version but they're
almost as good.)

A young lady, Miss Reynolds, came round from the
Prudential about the extra insurance cover on
the photographic equipment. I made tea and
arranged some biscuits on a plate. While she was
filling out the relevant forms I started trying
to impress her by putting as many Jammy Dodgers
in my mouth at once as I could. XXXXXXXXX
XXXXXXXXXX Afterwards I felt rather foolish.
I was just showing off I suppose. I asked her if
she'd care to see my new darkroom but she
declined saying she had another appointment.

'ANGEL' MAN FOUND NAILED TO

TUESDAY, MARCH 14, 1959

Exhibit **5**.

After she'd gone I was idly leafing through one of the old newspapers from the box when I made the most startling discovery. Could this murdered man and my own angel be one and the same? Now that I look at 'Guiding Light' again I can see that perhaps it might indeed be a man from Whetford nailed to his bedroom ceiling, and not the holy vision of an ethereal being.

How do you go about nailing someone to the ceiling? They'd have to be dead first, or unconscious. What a peculiar thing to do. It must have taken at least three men to lift him. But why pose him as an angel?

What's really annoying is that the rest of the newspaper article is missing. For a while I thought someone back in 1959 had cut something out. I could have kicked myself when I realised what was previously on the XXXX other side. 'Look What the Hound Found!' And where is that picture? Pinned to the board in the Camera Club meeting room. I must get it back because the piece is bound to disclose the identity of the victim. Murder victim, as the word 'found' in the headline would suggest. I wish

there was a police picture taken at the scene of
the crime so I could make sure my 'angel' man was
the same. If he was, then this camera is surely a
vital clue. Who took the picture and why? My guess
is that it was the murderer himself. So whoever
owned this camera, my camera, might well be the
murderer. But that would be the man from Wooton
Green. Somehow I can't picture it, he doesn't seem
the type. Did someone have the camera before him?

There might be fingerprints still left on it that
could provide a clue. I expect I've replaced them
with my own by now. Damn. If only I'd known, I
could have worn gloves. Better not touch it again
until I've dusted it for prints.

I rang Alistair to get 'Look What the Hound
Found!' back but his wife (I assume it was his
wife) said he was away on a walking holiday in
the Lake District and won't be back until
Thursday. I wonder why she hasn't gone with him.

I got into a spot of bother at Aynsley Downe
School. I'd taken the bus over there to see if by
chance the pictures from last week's meeting were
still pinned to the board. (They weren't. He will
have taken them home I expect.) I could see into
the classroom (B3) from the playing field side.
Having jumped the ditch that runs alongside the
cinder path, I had pulled myself up into the
bushes by the classroom window. All the children
were at their desks but there was no teacher in
the room.

Sitting at the back were two boys swapping bubble
gum cards and I was suddenly reminded of the
Agent X series of detective cards I collected as
a boy. They were mostly pictures of Agent X in
various heroic detective pursuits, though some
were of attractive female spies, hostages etc.
(occasionally in their bikinis or night attire.)
I never managed to get any of those. All mine
were of Agent X. My collecting must have been
interrupted, I suppose because that would have
been around the time Mum died. Nan didn't tell me
what had happened for ages, more than a year I
think. I spent a long time wondering where my
parents had gone. I was quite happy living at

Nan's, and I was going to school as normal but
deep down I knew something was wrong. Whenever I
asked her she just said 'they're on holiday.' It
was only later I found out that Mum had killed
herself. I think I sort of knew it was going to
be something like that. Apparently Dad left the
same night and no-one ever heard from him again.
Then XXX one day Nan went up to the school and
must have told Mrs. Moorcroft because next morning
it was announced in assembly and everyone looked
at me. I didn't know what to do so I laughed. I
loved those Agent X cards.

I was just about to leave when I noticed two XXXXXX
teachers eyeing me suspiciously and whispering to
each other. One of them made her way over to me,
"Excuse me, but what are you doing?" she said. I
told her I wasn't doing anything. I didn't like
her accusatory tone and I wanted to get away. In
my attempt to do so I stepped into the ditch and
felt my shoe fill up with cold water. I tried to
push past her but she stood in my way saying,
"Just a minute, I'm not finished with you yet."
"Leave me alone. I haven't done anything," I
said. I hurried past her and made off down the
lane, my right shoe making a squelching sound and
my sodden shoe collecting XX black dust from the
cinder path.
"I'll get the police onto you," she said.

Now I'm back home I have put my wet shoe on the
radiator to dry. I'd like to go back when that
nosy teacher is out of the way. (Looked out my
old Agent X cards. I've only got 14, I thought I
had more.)

With the newspaper headline throwing new light on
'Guiding Light' I decided to re-examine it for
further evidence. I can't imagine how I didn't
notice it before. Now it seems obvious. The wall-
paper in the background is the same as in 'Beauty
Unadorned'. Both pictures were taken at the same
location. And despite the Rolleiflex being a very
popular camera in 1959 it seems more than
coincidental that both pictures were taken with
the same type of camera.

Same day. 7.41 p.m.

There was nobody serving at Brumfit's. I called
in just before closing for some talcum powder. I
waited in the shop for someone to come but there

were no signs of life. I realised I could have put
something in my pocket without anyone knowing but
I couldn't think what to take. I picked up a
barley sugar twist and fed it up the sleeve of my
jacket before thinking better of it and putting
it back. I was confronted by a strong sensation
of having been there before in a similar situation,
perhaps as a boy.

After a while I decided to go and investigate out
the back. There was a flight of stairs which turned
a corner up to the first floor and at the turn was
an old W.C. At the top of the stairs XXXXXXXXXX
there was a large wardrobe. Beside it cardboard
boxes had been piled to the ceiling. Those at the
bottom had developed rounded corners where the
weight from those on top had squashed them. I
thought I could hear breathing but it was just the
toilet cistern refilling.

I called out hello and knocked on one of the doors.
No-one answered so I went in. The room seemed like
it was used for storage, more boxes draped with
blankets. The air seemed cold and still as though
no-one had been there for years. It was a horrible
room really. Lino on the floor and a damp patch in
the corner where the wallpaper was coming away from
the wall. I parted the curtains a little and peered
through the dirty window that looked out onto XXX
St. Alban's Road. I suppose I was hoping to find
something photographic to connect the room with the
Studio Arts Club, an old lighting stand, a roll of
backdrop paper but there was XXXXXXXX nothing.
I checked the ceiling for nail holes but there
weren't any. It was the original ceiling too, it
hadn't been replastered or anything. Then I looked
at the wallpaper again. It's the same XXXXXXXXX
paper as in 'Guiding Light' and 'Beauty Unadorned'.
I felt sure of it but I cut a sample from the wall
with my penknife to check later at home.

Still nobody serving downstairs so slipped a XXX
container of Old Spice Talc for Men into my coat
pocket before leaving.

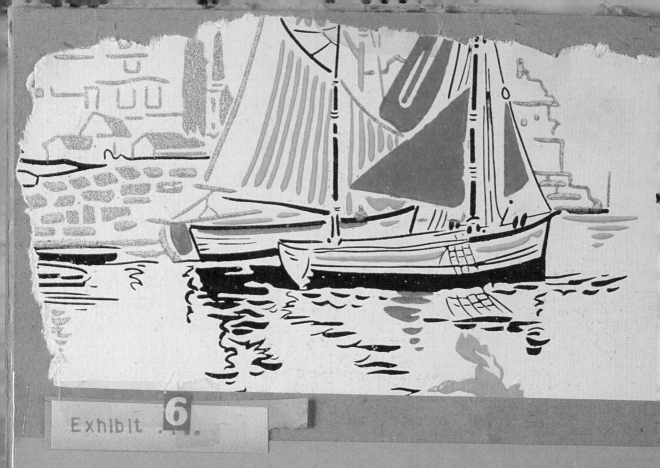

Exhibit 6

Well. Things are really hotting up now. This is
definitely the same pattern wallpaper. I'd have
said this was where both photographs were taken
except for there being no nail holes in the
ceiling. It doesn't add up. Perhaps this was a
popular wallpaper and lots of people had it.

Busy day ahead tomorrow. A heinous crime has been
committed and my Rolleiflex has witnessed the
whole thing. I need to find out who owned the
camera in 1959. Was it the man from Wooton Green?
Was he a member of the Studio Arts Club? I'd
like to ask him a few questions. Pity cameras
don't come with a log book like a car, stating
previous owners. Who was the victim? And who
killed him? Somebody connected with the Studio
Arts Club I shouldn't wonder. Brumfit himself?
Who is the woman in the picture? Did she have
something to do with the murder? And where did
Middleman get that box of magazines from?
What if the dead man was pointing at the magazine
to try and identify his killer. So many questions.
And by hook or by crook I will find the answers.

Well method doesn't work.
Admi I used to dust the camera
was at was revealed was a XXX
smud ore, now the focus sticks
a bi t have got talcum powder
into . Having taken my own
fing der to eliminate myself
from yself with nothing to
matc to do this properly.

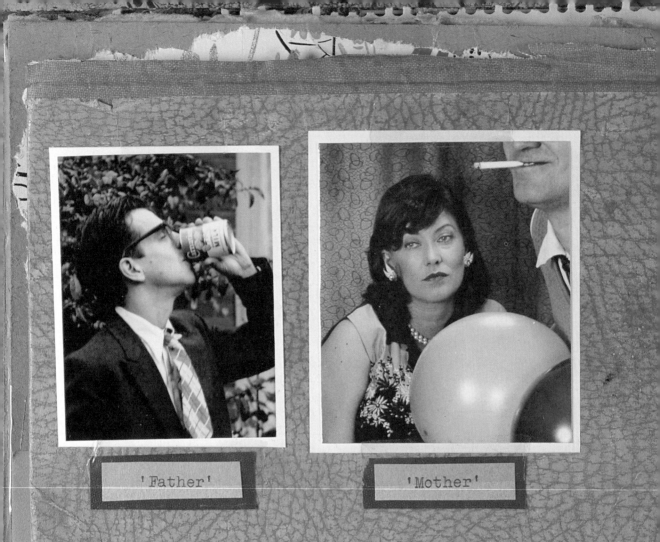

'Father'

'Mother'

ceiling. It doesn't add up. Perhaps this was a
popular wallpaper and lots of people had it.

Busy day ahead tomorrow been
committed and my Rollei whole thing. I need to
camera in 1959. Was it een?
Was he a member of the X
like to ask him a few don't come with a log g
previous owners. Who w killed him? Somebody c lo
Arts Club I shouldn't ?
Who is the woman in th something to do with t id
Middleman get that box What if the dead man w azine
to try and identify hi tions.
And by hook or by croo ers.

AGENT X

A SERIES OF 60 CARDS

42. Touch Typing

Ever resourceful Agent X does a
makeshift check for fingerprints by
dusting the attache case he had left in his
hotel room with talcum powder. Having
wiped the case clean before he went out,
he knew that any prints that showed were
not his own. He was later able to identify
the culprit by matching these prints with
those left on a wine glass by the beautiful
Amanda, daughter of the head of a
diamond smuggling ring.

ACE CHEWING GUM LTD. ENGLAND

Alistair's wife wore a smart ██ green suit and was
much more tidily dressed than I'd expected. Not

Caught the bus to Wooton Green, (quite a poor
area, sex with homeless type) thinking his phone
may have been out of order but there was no
answer when I rang his bell either. Looked through
his letterbox and there was quite a build-up of
post so he could be on holiday.

Fingerprints of self. Exhibit **7**

Th 1 2 3 4 Right

4 3 2 1 Th Left

Well in reality Agent X's method doesn't work.
Admittedly the paintbrush I used to dust the camera
was a bit stiff but all that was revealed was a ███
smudgy white mess. Furthermore, now the focus sticks
a bit and I'm afraid I might have got talcum powder
into the camera's workings. Having taken my own
fingerprints in ███████ order to eliminate myself
from the enquiry, I find myself with nothing to
match them against. I need to do this properly.

Rang Alistair's wife again. Told her I
Needed my 'Look What the Hound Found!'
picture for my assignment and could she
possibly look through Alistair's things
to see if she could find it?
(Conversation recorded at 3.18 p.m.)

Well I'd like to be able to help Mr. Whittingham
but I'm rather busy and Alistair had so many
pictures in his studio, I wouldn't know where to
start looking.

That's all right. I would. I'm sure I can
lay my hands on it if I could just pop
over and have a quick root ~~XXXXX~~ around.

Can't it wait until he comes back?

I wish it could Mrs. er...but it really is most
urgent that I have it. I can be there in five
minutes. I'm only the other side of the park.

Well it would be rather inconve...

Won't take a minute. I promise.

Quickly slipped my tape-recorder into my coat
pocket and changed into my corduroy slacks
before setting off across the park. Having
decided to take the Rolleiflex with me as a way
of authenticating myself as a genuine Camera
Club member, I was faced with a fingerprint
quandry when I was unable to find my gloves. I
hadn't time to look for them properly so
instead got a pair of marigolds from under the
kitchen sink and wore those. Pulled my cuffs
down over them so they didn't look too ~~XXXX~~
conspicuous. I don't know why they don't make
them in neutral colours.

Serenade
Also in Silk & Eggshell Exclusive

Alistair's wife wore a smart XX green suit and was much more tidily dressed than I'd expected. Not like Alistair at all. I'd expected someone a bit more arty looking considering her husband's line of work. Denim-look slacks with a broad ribbed husky tank-top, that sort of thing. She had red hair and very pale skin. Almost translucent. Her pale blue eyes were fringed with tiny sticks of black mascara. A very handsome woman, I'd say.

When the door opened in response to his knock, Johnny was literally unable to speak, unable to comprehend, unable to do much of anything except gaze and gawk in the same way Ben Lipper would react upon seeing a beautiful young woman naked.

Only Marla Karlson wasn't naked...not exactly.

The bubble coiffed blonde hair, in all its natural golden highlight, radiated up and out in a sassy French pouf from her sparklingly refreshing face. Johnny saw the face only in passing though. His eyes were far more intent, far more mesmerized by the soft look of bare flesh that flowed and curved so

smoothly beneath the sheerest pegnoir he had ever looked right through.

Two firm breasts stood brazenly erect, pushing out at the gossamer covering until the mesh hung down with as much intrigue as the thick clothed brunch coat did that night in the elevator. The legs were long and shapely, adding an illusion of height to Marla's sumptuously carved five foot three frame. And she had the left knee bent at a cocky angle to match her provocative stance.

She also wore a slim, red panty brief.

"Hi!" she smiled saucily, a pensive red glow to the full, sensuous lips, "Don't just stand there. Come in."

Mrs. Williams opened the door only slightly and firmly stood her ground. She clearly did not intend to let me in.

I've had a good look in Alistair's studio and I'm afraid I can't see your picture. I'm very sorry.

She went to close the door.

Don't be sorry Mrs. er...

Williams.

That's because you don't know the picture you're looking for. I think I can spot it if I could just...

She reluctantly let me in.

...have a quick root so to speak. I wouldn't bother you but I need the picture for the assignment I'm working on.

No need to tell her about the enquiry. I tapped my camera to indicate the nature of my work and it was then she noticed the rubber gloves which seemed to unsettle her.

I laughed it off.

Oh, don't worry about these. I'm only wearing these to avoid fingerprints. It's part of my assignment actually but I won't bore you with the details. I'm sure you're very busy. Is it up here?

If you don't mind, Mr...

Whittingham.

...I'd really prefer it if you'd wait until my husband is here.

I was already on the landing. I could see a room converted into a studio, lights on stands, photos on the wall and a big velvet curtain hanging up.

Won't be a tick, I promise.

My eyes darted round the room taking it all in. Marvellous. It was all extremely artistic and professional and I wanted to remember every detail so that I could recreate the same effect at home in the spare XXXXX bedroom.

Mr. Whittingham. If you don't mind. I really think...

Of course. I'll just er...

My eye caught a pair of nude studies pinned to the wall. I leaned over the desk to inspect them more closely. One woman lying XXXXXXXXXXXX artistically next to a piece of driftwood, the other looking statuesque on a clifftop overlooking the sea.

"See something you like?" she teased the query, letting the tip of her suggestive tongue rest questioningly on the bottom lip.

Oh, I say. How splendid. Yes, I like these very much. Marvellous composition, don't you agree? Yes, very attractive studies. This isn't you, is it, Mrs. Williams?

No, it isn't.

No? I wasn't sure. Because there is a resemblance, although I can see this was taken a few years ago. Do you ever pose for your husband, Mrs. Williams? You know, for figure study type pictures?

Mr Whittingham, I really must insist...

Don't misunderstand me. Nothing wrong with a photograph of the naked human form.

for Artists, Photographers, Students of the Human Form

A Treatise on the Aesthetics and Techniques of Nude Photography

You have heard it all before. The controversy has always been there. Seldom does it really rage except when somebody enters the discussion who is basically opposed to any kind of portrayal of the nude. But also occasionally you find someone completely at variance with the general opinion.

FIGURE PHOTOGRAPHY

The Nude in Photography

All photos are in "low key"- an artistic method dramatically suited for this type of work.

The rich, unfolding grace and intimate curves of the female figure in light and shadow.

studies which are technically and æsthetically of a high degree of excellence.

The Technique of Nude Photography

the nude for photographer and art student.

Never before have nudes been presented with such dramatic and artistic intensity and using such novel modern photographic techniques! These close-up studies of the female form have a startling quality of sensual boldness.

BODY IN ART

For artists, sculptors, students of the human figure.

ARTIST'S MODEL

...ing her sexy qualities.

I could see Mrs. Williams was getting annoyed.
You'd think she'd be more tolerant about this
kind of thing being married to a semi-
professional herself. Some people just can't
differentiate between art and smut.

I spotted the postcard of Cezanne's fruitbowl
on top of a pile of other pictures and discovered
'Look What the Hound Found!' underneath it.

Here it is. This is what I need.

The gloves made
it difficult to pick up but I finally managed
to put it in my pocket. Mrs. Williams followed
me down the stairs and ushered me towards the
door which she held open for me. I thanked her
for her trouble and left. Not at all bad
looking that Mrs. Williams. All frosty and
business on the outside but underneath all
black bra and nude posing.

Walked back across the park reading the
reverse side of 'Look What the Hound Found!'

So Brumfit was the angel. I had my picture upside-
down all the time. He was nailed to the floor, not
the ceiling. A fallen angel. No wonder I couldn't
find any nail holes. I should have been checking the
floor. Well I suppose I can cross Brumfit off my
suspects list. Why didn't I recognise him?

I wonder if the police ever ~~kkkk~~ caught the
murderer. Doesn't sound like they were getting very
far with their investigations. I know more than
them, although that brooch sounds like a big clue.
Det. Sgt. Watkins seems pitifully unaware of the
significance of the stolen camera. My camera (or
Brumfit's as it was then). Oblivious to the fact
that the murderer took a photograph of Brumfit
('Guiding Light') before fleeing from the scene
with it.

Exhibit 8

Things seem to be pointing to the direction
Green since the camera was in his posession,
albeit 35 years later. This however doesn't
explain the crescent moon brooch.

I think two ginger biscuits will
help me ~~XXXX~~ consider the p...

NAILED TO FLOOR

INVESTIGATIONS are underway into the brutal murder of local chemist Gregory Brumfit whose body was found nailed to the floor of the photographic studio above his shop, Brumfit's Pharmacy, on St Alban's Road, Whetford yesterday morning.

Police believe the attack took place on Friday evening while Mr Brumfit was working late although his body was not discovered until Monday morning when a neighbour, Mrs. Emily Ashcroft, decided to investigate. "I thought it odd that the shop was closed all day Saturday but when it wasn't open again on Monday I felt something might be wrong.

"The door was unlocked so I went inside to check everything was all right. In the front room upstairs I found Mr Brumfit lying on the floor. I didn't notice the nails at first but I could see he was dead. His white coat was splayed out like he had wings and I remember thinking he looked like an angel."

BIZARRE

Although a camera worth £125 was stolen from the photographic studio, cash and other valuable equipment had been left behind. Said Det. Sgt. Watkins, "We are not convinced that the motive for this crime was robbery since it would not explain the bizarre method by which the victim was killed." Mr. Brumfit, who was unmarried and lived alone, apparently died from a blow to the head before he was pinned to the floor by 4" nails through his clothing.

SHOCK

The people of Whetford are understandably still in a state of shock over the news. Said one local man, "Nobody can believe this has happened. Mr. Brumfit was always such a well-liked man.

It's unimaginable that anyone could do such a thing."

Police investigations into the case have so far drawn a blank, though detectives remain optimistic. "It's early days yet. But little by little we're piecing things together. There were no signs of a forced entry so it's possible the victim's attacker may have been known to him. We found little evidence to suggest there was a struggle, although a photographic lamp was found laying face down on the floor, the heat from which had badly scorched the boards. It's possible the murderer intended to start a fire to destroy any evidence."

BROOCH

Detectives have yet to come up with a plausible theory that would explain the strange circumstances of this murder but believe that a brooch found at the scene of the crime may provide them with their strongest lead. The brooch measures approximately 2" and is made of fake gemstones in the shape of a crescent moon. Said Det. Sgt. Watkins, "We would urge any member of the public who recognises this piece of jewellery or who has any information that might help us to solve this case to come forward."

TV shop put up 'so...

"**S**OLD OUT" notices wi... shop selling televi... through from manufacturers

The abolition of hire purcha... restrictions last week set off... chain reaction of buying by t... public which has kept local de... lers working day and night to kee... up with the demand.

Typical is the firm of Kirby's... Crossley Bridge which has cleare... hundreds of TV sets during t... week. The manager, Mr. S. Kne... said: "I have done seven or eig... times more business in renti... sets this week and have sold mo... than three times so many or t...

...ing her sexy qualities.

I could see Mrs. Williams was getting annoyed.
You'd think she'd be more tolerant about this
kind of thing being married to a semi-
~~~~~~~~~~~~~~~~~~~~~ Some people just can't
~~~~~~~~~~~~~~~~~~~~~ rt and smut.

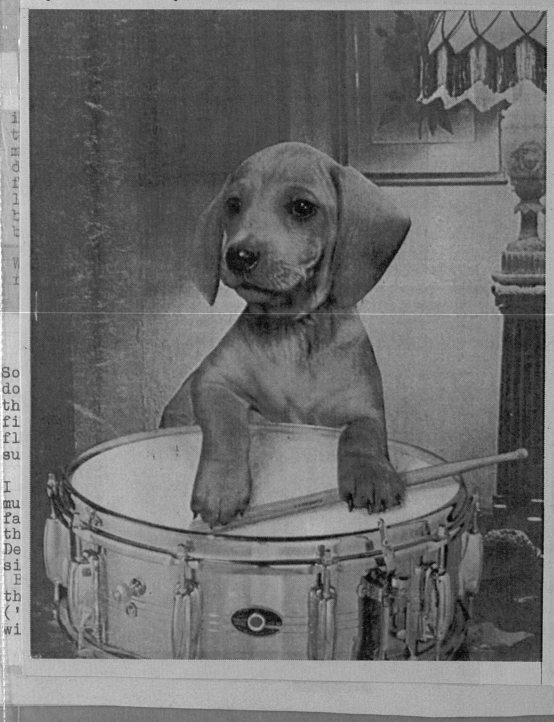

Look What the Hound Found!
Looks like Biffer's trying to drum
up business for the new shop!

Things seem to be pointing to the man from Wooton
Green since the camera was in his posession,
albeit 35 years later. This however doesn't
explain the crescent moon brooch.

I think two ginger biscuits are called for to
help me xxxx consider the possibilities.

It's safe to say the murderer was probably
connected with the Studio Arts Club. The man from
Wooton Green could have been a member but then
so could Middleman. So could Alistair, come to
that. Motive? Some argument on Club night over
one of the models? Passionate jealousy inflamed
by the lewd nature of the work? You can see how
it might happen, though nailing someone to the
floor seems overly harsh.

On the other hand, if the murderer was a woman,
as suggested by the brooch clue, it could have
been one of the models. -Though up to now the
only one confirmed as photographed at that
location is 'Beauty Unadorned' the woman with no
head. Could this woman be Mrs. Williams? She
seems xxxx too young to have been posing all that
time xxxxxxx ago but who knows, she may be older
than she looks. She could easily have been posing
for the Arts Club as well as for Alistair. Her
voluptuous shapeliness would have been much in
demand for figure study work. Motive for murder?
Brumfit refused to pay her for her modelling
services? Blackmail perhaps? But how could he do

that when she's quite clearly not at all
backwards at coming forwards in the night attire
department? And it wouldn't explain how the
camera came to be in Mr. Wooton Green's hands.

If one of the other models did it, then Mrs.
Williams - if Mrs Williams is 'Beauty Unadorned'
- would at least know their names. If I could
persuade her to do a modelling session with me,
I could always bring up the subject nonchalantly
whilst emboldening the fulsome loveliness of her
womanly charms.

beautiful face, long soft hair, curvaceous figure. Lacy
blouses or negligees, low-cut evening gowns, feminine
and revealing dresses are perfect apparel for empha-
sizing her sexy qualities.

SOONER or later, everyone who work
with a camera, either as a hobby or a
business has tried nude photography. When
done in an artistic manner, it is one of the
most difficult projects the photographer
will encounter and reveals the caliber of
his creative integrity by the way he handle
the subject.

IT is really amaz-
ing just how
much trouble legs
can give to the man
behind the camera—
in the strict photo-
graphic sense of course!
To get them to photo-
graph well and yet to
pose them in a way
which is not too
standardised is one of
life's constant problems
for the glamour photo-
grapher.

The idea then is
to find her best feature and accentuate it.
For example, if your girl has beautiful legs, look for
poses that emphasize them. Get your camera low so

Learn to recognize the good poses. You and your
model can get to know the good poses by studying
the magazines and keeping a file of pictures that you
like. Take this file with you the next time you go
out to take pictures. You needn't copy the pictures
exactly, but one pose usually suggests a dozen more.

Wednesday 7 DECEMBER,

Can't think what I've done with the Weetabix I
bought yesterday. It's nowhere to be found. I
must have left it in the shop but now I can't
actually recall buying it.
Must have my Weetabix for breakfast. The day I
doesn't start properly without its wheaty good-
ness inside me. I've been having Weetabix every
day since I started school. My father would have
it too sometimes but he would spread butter and
marmalade on it like toast. This always struck
me as a peculiar choice and I could never work
out where he got the idea from. I have hot milk
on it in winter, cold in summer. And a bit of
sugar on it. Lovely.

Decided to opt for synchronised flash equipment. Alistair's studio had the usual spots and fill-in flood but the modern photographer knows that most models today prefer flash to baking under hot lights. Alistair's probably a bit old-fashioned in that department. His wife probably didn't like to say anything. Middleman has provided me with everything I need. All my savings gone but it's vital to my investigation to question Mrs. Williams and check for the triangle of freckles on her shoulder. The only way to do that is to get her to pose for me. Can't do that without a professional studio.

78

a drawer. "Okay. Let's get with it. You can undress behind that screen if you're modest."

"Do we take the pictures here?"

"Where else?"

"I'm sorry. It—it just doesn't look like a studio."

51

in your studio. Now whether you have a professional photographer's studio or whether you take your pictures in an old garage, always refer to it as your studio. This is extremely important when working with figure models especially since many of the girls you will be working with will be doing this sort of thing for the first time. It is very important that they feel that they are posing for artistic pictures. A big help is to have some samples of your best figure studies on hand around the studio, either in an album or framed on the wall. In this way prospective models can see the sincerity and quality of your work.

The photographs which you choose for these samples should be especially impersonal and not show the face of the subject enough to identify her. This is to reassure the model prospect that you will not be showing pictures of her in the nude to anyone who happens to come in.

70

Spent most of the morning setting things up. Had to move all the furniture from the spare bedroom into the garage, then I set the scene by putting up the cork notice board from the kitchen. Pinned up several of my favourite photographic studies from the magazines, taking care to obscure each of their faces adequately.

In the afternoon I practiced lighting set-ups with
the doll I found in the little boy's garden. I've
called her Gloria. Always liked the name Gloria. As
you can see, she's quite photogenic. Had trouble
with no. 3 because every time I turn her upside-
down her eyes close. Rather than glue her eyes open,
I had the brainwave of doing the whole thing upside-
down and then simply turning the print. All in all
I'm rather pleased with the results.

Mrs. Eckersby had her gentleman caller in again. I
saw him knocking on her door as I was going out. He
looks like the photographer type. I wonder if she's
posing for him. He didn't seem to be carrying any
camera equipment but he could have had it hidden
under his coat.

1 Peep-Bo.

Gloria's most attractive
features is her carefree
air of insouciance, a can-
did appeal that is almost
irresistible. By posing
her in a not-too-revealing
neglige and composing
his pictures with a
slightly old-fashioned air,
our amateur has endeav-
oured to bring out that
Alice - in - Wonderland
charm that makes Gloria
so delightful a model.

In some of these pic-
tures, at least he has suc-
ceeded.

page fifteen

Single spotlight with fill-in flood. Synchro-flash.
1/5th @ f.16 on Ilford FP4 film.

2 Inquietude.

3 Form and Line.

Called in at Spar to see if I'd left my gloves there yesterday. Or my Weetabix. Turns out I didn't leave either. Walked across the park and caught a bus from there hoping to catch Mrs. Williams as a number ten on her way to work or to the shops. No luck. Had sex with ugly traffic warden and elderly woman with shopping trolley. Very disappointing. Doreen, my cheesecake charmer, not at Patterson's. Day off, perhaps?

White plastic bra, 20p from Oxfam Shop 'miscellaneous toys' box. (Actually too small, used tape to fix it) Negligee/underslip created from bits cut off front room net curtains.

4 Portrait de Jeune Femme.

5 Charme.

I'm surprised Brumfit's have got any stock left.
Every time I go in XXXXX it seems there's nobody
minding the shop. Pity, in some respects. I'd like
to ask the woman more about the murder, now I
know why she was so guarded that day.

In no time at all I was upstairs in the old
studio again. The curtains were drawn so I put
the light on. The switch sparked as I flipped it,
then continued to fizzle so I left it on. Faulty
connection somewhere, or condensation from the
damp.

I'd remembered some of the boxes had writing on
them and I wanted to XXXXXXXXXXX take another XXXXX
look. I turned some of the boxes round to read
the words more clearly. 'Eve,' 'Raised Skirt,'
'Continental,' 'Bosom,' 'Fronts,' 'Backs,'
'Outdoor,' 'Lingerie,' 'Artistic'. I knew
immediately what all this was about.

I tried to get into 'Lingerie' but the boxes on
top weighed a ton so I had a go at 'Artistic'
with my penknife.

guided by the
eye of an artist, the camera can become a means of conveying beauty the
artist himself has seen. In this way photography can become a very personal
means of expression, and in the hands of an artist the camera can give pictures
of real artistic value. /

Once it was open I quickly flicked through a dense
collection of tightly packed glossy photographs.
All on the classical art theme; nymphets at the
water hole, wispy chiffon and dusky maidens with
large X Grecian urns, that sort of thing. Some
really marvellous shots. But when one picture
particularly caught my eye, I knew I had my answer.

I suddenly heard a door slam downstairs. In my
panic to conceal the photograph about my person, it
soon became apparent that I didn't have a pocket
big enough so I quickly lifted my shirt and
stuffed it down the front of my underpants,
hastily re-tucking as the door opened.

I was face to face with the woman from the shop.
She looked startled.
"Can I help you?" she said suspiciously.
The picture felt cold and stiff against my skin.
"I'm so sorry. I was looking for the Studio Arts
Club."
"Studio Arts Club? Oh, it's you Mr..."
"Whittingham, yes." I was trying to xxx push past
her.
"Well there's no studio here. I told you that."
"Oh yes, so you did. Sorry, I forgot. Oh well,
I'd better be going."
"Just a minute."
"No. That's fine. Thankyou."

With that I was able to make my way past her down ~~XX~~
the stairs and out into the street.

I had to walk back home with the photograph down
my trousers. It had warmed up by this time but
the sharp edge was having a kind of guillotine
effect on my loinal area and the corners were
sticking into my upper thighs with each step I
took. I considered nipping into the public ~~XX~~
lavatories at Churney Park to relieve myself
of it but when a man loitering outside smiled
at me, I thought better of it.

I was just about to turn into my driveway,
anxious to inspect the evidence when I noticed
a police car with two policemen sitting in it
parked a few houses along. They pretended not
to be watching me but I knew they were, so I
made ~~XXXXXX~~ as if I'd forgotten something and
turned down Silsey Avenue so that I could cut
through to the alley at the back of the house.

When I got in I took care not to turn on any
lights. I peeked through the curtains. They'd
gone, probably on a wild goose chase looking for
me. As long as I keep quiet and don't answer the
door, they won't know I'm here. I'm writing this
by torchlight. I hope my batteries don't run out.

POLICEMAN

guided by the
a means of conveying beauty the
graphy can become a very personal
artist the camera can give pictures

So this is the murderer. Everything points to it.
Angel wings. Brooch. Three freckles. This has to
be it. You can see the crescent moon brooch is
actually a hair slide, otherwise it fits the
newspaper description perfectly. 'Beauty Unadorned,'
and the woman in this picture are one and the x
same. And this xxxx was taken at the Studio Arts
Club xx because the same wallpaper is showing
underxx the back-drop paper.

But is it Mrs. Williams? Although her face is
turned away, she does have the comely look of Mrs.
W about her. I wonder what the title of this one
was going to be. 'Heavenly Body,' perhaps? Well,
she's no angel, that's for sure. I know what she
gets up to. First taking her clothes off and
then nailing a man to the floor. What xxxx kind
of behaviour is that?

Strictly speaking, I can't be sure this is Mrs.
Williams until I make my final check, but I bet I
could get more evidence if I went back to
Brumfit's. All those boxes full of glossy photos.
My heart started racing at the thought of how
much hard evidence such a collection would yield.

How am I going to get hold of them? If all those
boxes contain 'collector material', as I suspect,
even if I manage to get them out of the shop,
how would I get them home? then I wish I'd taken
driving lessons now. There's a wheelbarrow in Mrs. Beckersby's
shed, I remember workmen using it in the summer
when they x were doing her wall. It will mean
several trips but that's all I can think of. If
only there was a Sainsbury's or a Safeway nearby,
I could commandeer a couple of supermarket trolleys.

Don't want to risk going out in daylight hours
just in case the police are still watching the
house. I don't know if the woman at Brumfit's
yesterday told on me, or whether it's that busy-
body young teacher from the school. Either way
I'm keeping a low profile. Can't afford to have
my investigations interrupted at this stage. I
waited in the bathroom/darkroom with the door
closed until it went dark before going out.

So this is the murderer. Everything points to it.
Angel wings. Brooch. Three freckles. This has to
be it. You can see the crescent moon brooch is
actually a hair slide, otherwise it fits the
newspaper description perfectly. 'Beauty Unadorned'
and the woman in this picture are one and the x
same. And this XXXX was taken at the Studio Arts
Club XX because the same wallpaper is showing
underXX the back-drop paper.

But is it Mrs. Williams? Although her face is
turned away, she does have the comely look of Mrs.
W about her. I wonder what the title of this one
was going to be. 'Heavenly Body' perhaps? Well,
she's no angel, that's for sure. I know what she
gets up to. First taking her clothes off and
then nailing a man to the floor. What XXXX kind
of behaviour is that?

Strictly speaking, I can't be sure this is Mrs.
Williams until I make my final check, but I bet I
could get more evidence if I went back to
Brumfit's. All those boxes full of glossy photos.
My heart started racing at the thought of how
much hard evidence such a collection would yield.

How am I going to get hold of them? If all those
boxes contain 'collector material' as I suspect,
even if I manage to get them out of the shop,
how would I get them home? I wish I'd taken
driving lessons now, then I could have hired a
van. There's a wheelbarrow in Mrs. Eckersby's
shed, I remember workmen using it in the summer
when they X were doing her wall. It will mean
several trips but that's all I can think of. If
only there was a Sainsbury's or a Safeway nearby,
I could commandeer a couple of supermarket trolleys.

Don't want to risk going out in daylight hours
just in case the police are still watching the
house. I don't know if the woman at Brumfit's
yesterday told on me, or whether it's that busy-
body young teacher from the school. Either way
I'm keeping a low profile. Can't afford to have
my investigations interrupted at this stage. I
waited in the bathroom/darkroom with the door
closed until it went dark before going out.

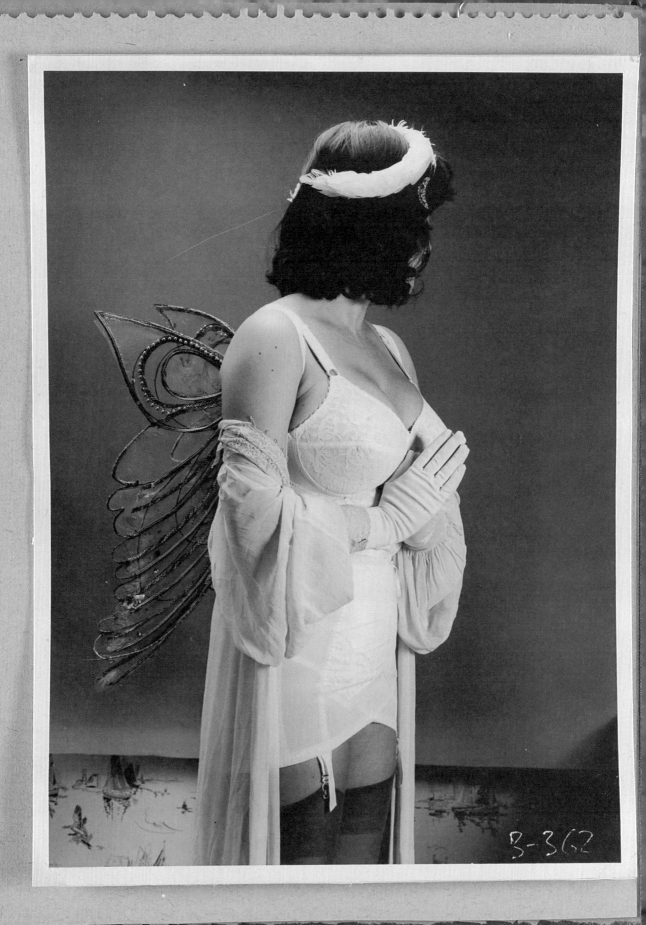

B-362

Exhibit ... **9**

It's been a while since I wrote my diary because I haven't had it with me, as the following will explain. So much has happened, I have to catch up.

Later. X Same day.

Let myself out through the alley, stopping to pick up the wheelbarrow from Mrs. Eckersby's shed. Felt horribly conspicuous XXXX on the streets with it. Some teenagers at the corner of Holroyd Avenue made fun of me. Should have worn gardening clothes.

Parked the wheelbarrow in the alley behind the shops and made my way round to the front to see what could be done about gaining entry. A small group of people across the street stood staring at the shops, their faces aglow with orange light. Brumfit's was on fire. There was a tremendous rumbling coming from inside the shop and flames had started to appear out of the upstairs windows. All I could think about was those bulging boxes of photographs. All gone. Nothing would survive.

Two fire engines arrived with deafening sirens and a lot of firemen ran around shouting. By comparison the fire had seemed quite peaceful. When a police car pulled up I decided to make myself scarce, heading back into the darkness of the alleyway. I knew the police would be on the lookout and couldn't decide whether I would incriminate myself more by walking back with the wheelbarrow or leaving it where it was. The police would be bound to find it, but would they be able to trace it back to me? Wiped my fingerprints off the handles with my sleeve and left it where it was. Made it back to the bottom of Inverclyde Road without incident. Bought two cheese and pickle sandwiches from the all-night garage. It was only when I reached the alleyway at Silsey Avenue that I hit a problem.

(I always go in the back way now so the police don't see me. They've taken to using un-marked cars so they're more difficult to spot. Obviously waiting for my house lights to go on which is why I've been okay until now.) As I turned the corner there was a man (plain clothes of course) in the alleyway pretending to be walking his dog. Naturally I couldn't go to my own house with him watching so I opened Mrs. Eckersby's back gate and

went into her garden instead. Once there I didn't ~~know~~
know quite what to do. I knew the man would be waiting
to see if I came out again. I didn't want to knock on
Mrs. Eckersby's back door, so quietly let myself into
her garden shed. It's rather a nice one actually and
there's quite a bit more room with the wheelbarrow out
of the way. I set up one of ~~her~~ her garden chairs and
sat looking out of the window contemplating my next
move.

Thursday 8 DECEMBER,
(127 999)

Must have fallen asleep. Woke up having dreamt that I
was back at school.

I am waiting outside the school until playtime. There
is a different teacher on duty luckily, so I chance my
my arm and slip into the playground hoping I won't be ~~noticed~~
noticed. Two boys in the corner with thick fistfuls of
Agent X cards. One boy flicks through his pile while
the other stands watching saying, "got got got got got
got..." I take my own cards out of pocket and go over.
I flick through while they both watch. "Got got got
got got got got got not got." He stuffs his cards into
his shorts pocket and from the other produces his
swaps. Several lady spies among them. I offer to swap
but before I can get a good look at them, the teacher
rings the bell and the boy whisks the cards from under
my nose, shoves them back into his pocket and begins
a strange uncoordinated march towards the door, his
arms and legs swinging stiffly in an attempt to prove
he isn't running. No-one seems to have noticed that
I'm a grown-up, despite my size, so I follow the other
children into the classroom and sit at the desk behind
him. The teacher asks us to write a story in our Busy
Books but I don't have a book to write in. I nudge the
boy in front asking him to lend me some paper but he
won't. I nudge him again but he won't turn round so
I lean forward and flick his ear really hard.

I tell the teacher I've left my book in the cloakroom
and she tells me to go and fetch it. I didn't know
where to go for paper. I find a blue crayon behind a
radiator but it needs sharpening. I go into an empty
classroom but can't find any paper that isn't written
on. Then I find some blank sheets amongst a pile of
stuff. I get lost and can't find my way back to the
classroom. Finding myself in a kind of store room,

I go through a door that opens out onto
the playground. As I start to cross it, I
see the school is on fire. Nobody else is
about. There is a red fire bucket full of
sand but I don't know what to do with it.

When I woke up I couldn't work out whether
the fire at Brumfit's had really happened
or if I'd dreamt it. Somehow the two
stories had become confused in my mind.
Sadly it was XXX not a dream. There was a
cheese and pickle sandwich on the camping
table and my coat smelled of smoke. The
photographs really had gone up in flames.

Rather chilly last night, particularly in
the small hours when my feet and knees
became numb with the cold. Had one of the
cheese and pickle sandwiches for break-
fast which had a touch of frost about it.
Decided to take a chance and sneak in the
back way to get my diary and typewriter.
Also sleeping XXX bag, blankets and various
other supplies. As I was coming down the
stairs a letter came through the letterbox.
It must have been delivered by hand because
there's no stamp on it. Took it back to
the shed to look at it which is where I
am now.

Exhibit **10**

BRUMFIT'S PHARMACY
G. BRUMFIT Dispensing Chemist
21 St. ALBAN'S ROAD, WHETFORD, WORCESTERSHIRE.
Telephone WHEtford 754

Wednesday 26 Jan 1959

Dear Frank,

In future, when you come in to pick up the films, I'd appreciate it if you could show a little more discretion. Your advert promised a private and confidential service. Just because you recognize one of the girls, that doesn't give you the right to start getting familiar. Besides, this one's out of bounds. I was in the back today, and I could hear every word you said. She doesn't know anything about Studio Arts, and I don't want her finding out, so kindly keep your nose out.

Also, remember what I said about any pictures of her being strictly for the home front. I don't want them turning up in one of those magazines. In fact, you can bring in all the pictures of her over to the shop. Negatives as well. I hope you appreciate the importance of discretion in this matter Frank. It would be awful if Marjorie were to find out about your extra-curricular printing activities

Gregory.

This letter's not to me. It's to Frank Middleman
from Mr. Brumfit. So who put it through my letter-
box? Sounds XXXX as if Frank was harassing some female
in the shop and Brumfit was warning him off. The
girl was probably doing a bit of posing for Brumfit
on the side but didn't know about his Studio Arts
Club set-up. No name mentioned but Brumfit seemed
keen to keep her for himself. Frank was obviously
doing the prints. I'd imagined he was somehow
involved. XXXX I bet those magazines that Frank
Middleman was dealing with were of the 'Eves without
leaves' variety. 'Strictly for the home front'?
I wonder what that means. Isn't it something to do
with the war?

> He tossed the prints on the bed. Debbie picked them up
> and gasped. They were two of the shots taken by Cynthia
> Boyle. "Where did you get these?"
> "A man where I work was showing them around. He
> says they sell them in packages somewhere on the West
> Side. I ran through them and found those—of you.
>
> "But, Mr. O'Hara. They aren't really *bad* pictures."
> "Defending your obscene nudity yet! Brazen! Forward!"
> "I'm not defending those pictures. I didn't know what
> they were going to be used for."

There's a lot about Frank Middleman that doesn't
add up. I need to ask him a few questions. Did he
leave the magazines by the bins so that I would find
them? Is he the one who delivered the letter?
(Tried the talc test for prints on the envelope.
Results inconclusive.)

Slipped out the back way. Man with dog had gone
so I don't think anyone saw me. With Alistair back
today I thought I'd call on Mrs. Williams again
while she's still on her own but she was out.
Funny because the lights were on and. ~~xxxxxx~~ I
thought I saw the curtains move as I walked up the
drive. Could she have been in the middle of a
figure study session with someone else? Thought
about visiting Frank Middleman but what would I say?

Stopped at Londis and bought sausage rolls and a
box of Mr. Kipling Viennese Fancies which were
on sale.

Mrs. Williams remained non-commital when I asked
her if she ever posed naked the other day which I
think is as good as admitting it. Since our meeting
she's ~~xxxxxx~~ doubtless talked to Alistair in
Cumbria who will have allayed any fears she might
have had about the legitimacy of my visit.
I just need to check those freckles.

Ask her to sit at 45°, only her shoulder towards the camera.

'Turn your head to the right.
Tip your head to the right.
Drop your chin.
Raise your chin.
Smile.
Eyes up a bit.
Eyes down a bit.
More smile . . .'

... You're a big girl. You know all the
facts of life."

Eyes are easily the most important single feature. All expression comes first from the eyes.

The glamour girl, on the other hand, requires a
more specialized wardrobe. Not all girls possess a
filmy negligee or a décolleté evening gown...

CARBON
COPY

Michael Whittingham
Photographic Artist
Glamour work a speciality
Telephone 6030456

Dear Mrs. Williams,

Many thanks for letting me pick up my Look What
the Hound Found picture the other day. Hope I
didn't inconvenience.

Forgive me for writing but you might just be able
able to help me out with an assignment I'm
working on for your husband's class tomorrow.
You know, the Camera Club. It's all a bit last
minute I'm afraid but isn't that always the
way in the glamour business? Ha ha.

Now, I'm working on a series of nude studies,
not unlike those your husband has on his studio
wall actually, and the girl who was modelling
for me has rather let me down at the eleventh
hour. Pity because she's a lovely thing and
very professional. She's thinking of going
into modelling full time but at present she's
working in a cake shop, Patterson's Patisserie
in Crossley. Do you know it? Anyway, she's let
me down and I'm rather stuck as a result. The
only other person I can ask is my next door
neighbour who occasionally does a bit of posing.
She doesn't do the full nude, more lingerie and
night attire, that sort of thing, which would
normally be adequate but on this occasion she's
not quite the ticket. You see the thing is,
she's blind. It's terribly sad, poor woman. It
doesn't usually matter for my kind of work but
in this particular series I need expression in
the eyes. I believe the eyes are the windows of
the soul, don't you, Mrs. Williams? And well,
sadly in her case the 'curtains are drawn'.

Now I couldn't help noticing your own very
striking blue eyes the other day and the full-
ness of your extremely well-proportioned
figure, and I thought since you're obviously
used to this sort of thing you might be able
to help me out. I wouldn't expect you to do
full nude of course. Probably just lingerie,
you know; pantie-corselette, stockings,
'beauty-lift' bra (black) with fibrefil under-
cup support, that sort of thing.

Perhaps you'd be good enough to phone me at
my studio (number above) to arrange a time
later this evening, (or tomorrow a.m. at a
~~push~~ push. Luckily I have my own darkroom
so at a squeeze I could print up the results
before tomorrow evening.)

Thanking you in advance.

Yours sincerely,

M. Whittingham

The glamour girl, on the other hand, requires a more specialized wardrobe. Not all girls possess a filmy negligee, or a décolleté evening gown; but usually, if they make an effort, they can borrow one, or even buy an inexpensive one that will serve for pictures.

 (No stamps so dropped this off at their house)

Darlene became determined, more serious now, dialing the seven digits of Johnny DeFranco's private number, groping through the telephone table drawer for a gold tipped cigarette and smudging it with deep red lipstick when she pressed it to her lips.

How am I going to hear the phone if she rings? I need a very long extension running down the garden to Mrs. Eckersby's shed.

Friday 9 DEC
(129,997)

Got up early and went into the house to listen out for the phone. Peeking through the curtains of the upstairs bedroom I watched a car across the road with two men in it move off, probably to get some breakfast. You can get pretty peckish on an all-night stake-out. Seized this opportunity to get in the studio for half ~~XXXXX~~ an hour before they returned.

The telephone rang!
"Forget it," Johnny ordered, not missing a motion.
Honey ignored it, prancing around the bed, twisting and turning her quivering body, the legs all the more shapely with the high heels she had put on. Then, with her mouth open in a hungry pant, the breathing heaving the jutting breasts in a wild sway that blurred into two circles. . . .
The phone blared again.

'Teeth' or 'No teeth' are technical self-explanatory terms
of instruction to professional models.

5. Pose the head last,

a broad smile

Right foot forward and crossed.
Hands in hip pockets.

Points to remember

1. All poses start with the feet. If a pose looks wrong,
F, change the position of the feet.

Silence Blanc.

if the girl looks good from a three-quarters back view with
head half tipped round, and eyes straight at you saucily smiling, you should be able to get
that effect whenever you want it.

Some interesting tips from Amateur Photographer
on how to give the model more allure. When I
tried to get Gloria to put XXX one foot in
front of the other, her leg came off at the hip
and I had to see to it with the Evo-Stick.
That's the trouble with the Gloria doll, she's
obliging but not very flexible. I could do with
some bendy arms like Action Man but I don't
want her with big biceps. I expect when I'm
dealing with the real thing it will all be
different. Movable arms and legs and the glorious
Mrs. Williams in any position I want her.

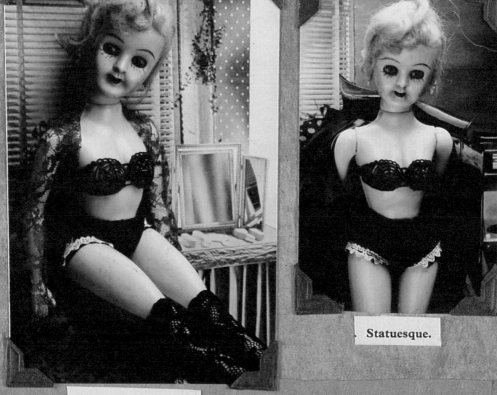

Nature's Simplicity.

Statuesque.

Door bell rang at 8.06. The post doesn't normally come until 8.45 so I was wary of answering the door. I checked from the bedroom and it was the postman but not the usual one with the funny teeth. I went XXXX to the door anyway and he handed me a package, but XX it was only my Freeman's catalogue. There was also a letter. The strange thing was, he wasn't carrying any other letters. Perhaps his van was parked round the corner. Or what if it was a policeman in disguise? I've seen them do that in films. I'll have to be careful.

Dear Mr Whittingham,

My wife tells me you have been pestering her asking her to pose naked in relation to a photographic assignment for my class. Whilst the study of the nude is indeed the topic scheduled for tomorrow's meeting, I want to stress that my wife is not a model "used to that sort of thing" and has never posed naked in front of the camera for me or anyone else.

My wife was distressed and offended by your request which she feels amounts to sexual harassment. I have assured her that your behaviour is the result of a misunderstanding about her profession and trust that in future she will have no further cause for complaint.

Yours sincerely,

Alistair Williams

I don't know how he feels he can get on his high
horse. Just to show them I know what's what, I
decided to make a 7x5" copy of the XXXXX
'Heavenly Body' angel picture under which I shall
write XXXXX "Ring any bells?". Let's see if that
'gives them cause for complaint' when it drops
through their letterbox.

"Simple as that, huh?" Johnny smirked, pulling
the black envelope from his pocket, "I guess you'll
say this was trick photography...composites of
when you used to pose in the nude for girlie mag-
zines Marla, maintaining a look of disinterest, pulled
the prints from the envelope. Immediately, the lack-
adaisical pose dropped. The young blonde tensed,
gripped tightly at the pictures and ground her teeth
together. The radiant face turned a pasty white.

No sign of the car outside so I decided while I
was in the dardkroom printing 'Heavenly Body', I'd
take a chance and print up what I had of Gloria.
I must have been in the darkroom quite a while.
I'd forgotten all about the police. I was just
getting my prints out of the fix when suddenly the
door XXX bell rang. Panic. What to do? Scooped up
the wet prints and crept downstairs, slipping
quickly through the back door and out to the shed.

Now I'm in serious trouble. I bet they found the
wheelbarrow. Why did I leave it there? That was
stupid. Now they're going to think I started the
fire. Even if I did, it was an accident. That
switch was faulty. Those teenage boys are bound
to come forward with a description of me, and my
leaving the wheelbarrow there is proof that I was
at the scene of the crime. And what with that
woman seeing me acting suspiciously at Brumfit's
the other day, I'd say I'm done for. The police
won't even bother to question me. I'll be in prison
before you can say knife. And what's more they
seem prepared to try and pin the murder on me
as well. I was just a boy at XXXX the time but I
don't suppose that'll make any difference to them.
If I don't find out who really did it, they're
going to blame me. There's only one thing for it.
I shall have to go under cover.

Time may be of the essence but I have been forced to
abandon my investigation for the best part of the
afternoon owing to my need to make sure my tracks
are covered. I decided some form of disguise was
necessary to avoid police detection while I XXXXXX
continue my search.

From a shop on Bettridge Road that specialises in
fancy dress, jokes and novelties, I bought a rather
convincing false beard and wig. Now I have them on I
would hardly recognise myself. And if the police go
asking questions at the shop they'll be put firmly
off the scent because during the time I made my
purchase, I disguised my voice by making it higher
pitched and walked with a slight limp.

Suddenly started thinking about the possibility of
having left footprints in the muddy ground behind
Brumfit's the other night. My shoes, only recently
having been re-soled would leave a distinct pattern.
With funds dwindling rapidly I didn't want to go to
the expense of replacing them with a new pair, so I
had the brainwave of having them re-soled again at a
different place. This I did in while-you-wait style
at a heel bar by the station. The man there said
they didn't really need doing but I insisted. (Used
high voice again which might have been unwise since
shoe repairer had high voice too.)

I have a strange feeling that someone's been here in
the shed while I've been out. I sensed the same thing
yesterday when I got back XX from delivering my
letter to Mrs. Williams but decided I was probably
imagining it. Today I returned to find my diary left
open as though someone had been reading it. My
scissors had been moved and there were a few off-
cuts off paper on the floor that I don't remember
being there when I went out. Checking through 'Lens
Lust' and other publications I'd swear some words
are missing, (other than those I have cut out myself),
although it's difficult now to guess what those words
might have been. Who could be doing this? Is it just
Mrs. Eckersby snooping around or are the police on to
my hiding place? I feel very easy about the idea of
someone meddling in my private things. What should I
do? Ican't take everything with me when I go out; I
I shall have to buy a good strong padlock for the
door tomorrow.

Nude study night at the Camera Club. Alistair
rang earlier having received 'Heavenly Body'X
and asked me not to come to the meetings any more.

Just because I found out about his wife posing nude. I desperately need to see her in her underwear for the purposes of my investigation. If she has the three freckles on her shoulder I can be sure it's her in the pictures.
If Alistair is having a nude study night, who's he going to get to pose? He's not going to pay out good money for one of the models from the art school. Not when he's got the lovely Mrs. I at home. She's clearly no spring chicken but she's in lovely condition.

UNDERWEAR ?

we always w

ST MARGARET by C

Time may be of the essence but I have been forced to
abandon my investigation for the best part of the
afternoon owing to my need to make sure my tracks
are covered. I decided some form of disguise was
necessary to avoid police detection while I ~~XXXXXX~~
continue my search.

From a shop on Bettridge Road that specialises in
fancy dress, jokes and novelties, I bought a rather
convincing false beard and wig. Now I have them on I
would hardly recognise myself. And if the police go
asking questions at the shop they'll be put firmly
off the scent because during the time I made my
purchase, I disguised my voice by making it higher
pitched and walked with a slight limp.

Recently I started thinking about the possibility of
having left footprints in the muddy ground behind
_____ the other night. My shoes, only recently
_____ re-soled would leave a distinct pattern.
With funds dwindling rapidly I didn't want to go to
the expense of replacing them with a new pair, so I
had _____ wheeze of having them re-soled again at a
different place. This I did in while-you-wait style
at _____ by the station. The man there said
they _____ really need doing but I insisted. (Used
his _____ which might have been unwise since
sho _____ and high voice too.)

I ha _____ feeling that someone's been here in
the _____ve been out. I sensed the same thing
yeste _____ot back ~~XX~~ from delivering my
lette _____iams but decided I was probably
imagin _____ I returned to find my diary left
open a _____ne had been reading it. My
scissor _____ved and there were a few off-
cuts of _____ floor that I don't remember
being th _____t out. Checking through 'Lens
Lust' an _____ations I'd swear some words
are missi _____n those I have cut out myself),
although _____ now to guess what those words
might have _____ld be doing this? Is it just
Mrs. Ecker _____ound or are the police on to
my hiding place _____ery easy about the idea of
someone medd _____vate things. What should I
do? I can't t _____ _____ with me when I go out; I
I shall have _____ strong padlock for the
door tomorrow

Nude study ni _____
rang earlier _____
and asked me _____

Just because I found out about his wife posing
nude. I desperately need to see her in her
underwear for the purposes of my investigation.
If she has the three freckles on her shoulder
I can be sure it's her in the pictures.
If Alistair is having a nude study night, who's
he going to get to pose? He's not going to pay
out good money for one of the models from the
art school. Not when he's got the lovely Mrs. W
at home. She's clearly no spring chicken but
she's in lovely condition.

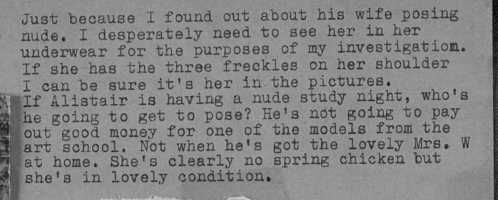

UNDERWEAR?

we always wear

ST. MARGARET by C

6 BRA-TOP NIGHT-
DRESS to put you in
shape for dreaming. New,
weightless shell-bodice
gives a flattering young
profile. Adorably feminine
in *Black*.
with lashings of lace.
F.2876 Size W..... 50/-

201

On the way I skirted St. Alban's Road and from the
roundabout could see that Brumfit's was in a
terrible state. The walls were blackened, though
still standing but the roof had gone. There was a
police car and various other vehicles parked in
front of the shop, and a small crane. Much
activity. X Even though no-one would have
recognised me in my disguise I decided not to
check to see if the wheelbarrow was still there
for fear of drawing attention to myself.

The Camera Club meeting room at the school had
black card taped to the windows in preparation for
the evening's session. I jumped the ditch and hid
among the bushes. The card only covered the
bottom half of the window so I tried climbing up
onto the window ledge but it was too high. I
found an empty milk crate to use as a step. Once
I was up there I found that by keeping my head
down I could just peep over the top of the XX
black card without being seen from inside. Alistair
was busy arranging a piece of velvet over some
sort of platform. There was a small electric fire
next to it with one bar turned on. Much commotion
amongst the others; loading film, adjusting
lights and taking light readings. (Or at least
staring at their light meters. Whether they were
able to read them or not is debatable.) No Mrs.
Williams as yet but it was still early.

I kept out of sight while I waited and just as my
knees were starting to go stiff I heard someone
coming up the path behind me. I kept still,
thankfully hidden by the shadows but turned just
enough to see who it was. XX To my surprise I
realised it was Doreen, my lithesome lovely from
Patterson's Patisserie.

At first I didn't put two and two together. I
thought she might be attending some other night
class. Pottery or ikebana. I was even thinking
about how I could join. Then I heard a door close
in the Camera Club room and looked over the card
to see her standing talking to Alistair. He was
indicating a makeshift screen in the corner. She
smiled and disappeared behind it. I couldn't
believe it. Doreen as a model. And any minute now
she was going to reappear fully unclothed as
nature intended.

Then suddenly, Darlene Damita, 131 pounds of pure sex rounded out at 38-24-38 in a five foot five frame, began to laugh with uproarious self amusement. She yanked off the top of the baby dolls, tossing them across a table. She paraded in front of the big mirror at the bar, eking narcissistic pleasure in observing the youthfully jouncy undulation of her projecting anatomy.

"You fool! You goddam stinking old man fool!" she mouthed out in a hysterical laugh to the vacant room, still twisting and contorting, "You like this, don't you...didn't you, you old fool?"

From my vantage point looking in I could see the top of her head moving about behind the XX screen as she undressed.

"You bitch! You...lousy bitch!" Johnny swore under his breath, but he didn't really mean it.

I was angry not to be in the classroom in the same close proximity as those lascivious leches with not an ounce of art appreciation between them, but nevertheless excited at the anticipation of seeing my curvaceous cutie in all her unadorned glory.

I was just feeling in my pockets for a piece of fruit and nut to complete the moment when I felt a tugging at my trouser bottoms. I slipped from the ledge and landed sprawling amongst the bushes. My wig came off. A man in brown overalls stood over me.

"What's your game, pal?" he said accusingly.

"None of your business thankyou very much."

"Well piss off before I call the old bill. Pervert."

"Pervert? It's not me who's perverted."

I ran off. Don't want the police after me again. Walked home feeling frustrated. She'd been so close. By now those idiots would probably have a few rolls of film tucked safely in their camera bags. I wonder if she did any french poses.

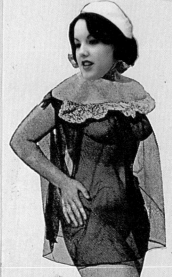
The glamour girl, on the other hand, should have a magnificently proportioned 39-22-37 body, stretching out every pulsating inch of her flawlessly smooth 5 foot 7 frame, and emitting a low heaving moan through the full lips.

Michael Whittingham
Photographic Artist

Studio Arts Club
67 Warmander Avenue
Whetford.
Telephone 6030456

Dear Miss Collar

As you will see from the above, I am a semi-
professional photographer specialising in studies
of the glamour and nature variety.

As a member of the Camera Club I am currently
working on a professional portfolio, my involvement
with which sadly prevented me from attending last
night's meeting where I understand you were engaged
as a model.

My good friend and colleague Alistair Williams at
the club has already informed me how XXXXXXX well
the session went and how splendidly you performed
in front of the camera. (And let me tell you, a
XXXXXXX really good model is a rare thing these
days.) So I wondered if you'd be interested in
broadening your modelling horizons by posing for
me here at my studio. (Usual rates of pay,
naturally.)

Leaving the technical aspect (of which I am fully
cognisant) on one side, I think I can safely say
that over the years I have learned a great deal
about hair, make-up, posture, grooming and all
aspects involved in training young models to pose
and would be glad to pass on this knowledge should
you wish to advance your career in this field.

I have all the facilities here at 'Studio Arts',
darkroom, lighting, camera etc. so there's nothing
to worry about on that score, but might I suggest
you bring along a few changes of costume? Swimwear,
lingerie, night attire (flimsy), that sort of thing.
Perhaps tomorrow evening would suit?

Naturally, as a member of the Camera Club I can
assure you of the utmost discretion in this venture.

I look forward very much to hearing from you.

Yours sincerely,

M. Whittingham

"Photogenic? Jesus! Yeah. You can make it, honey. You can make it big."

"Suppose he sells the pictures and I happen to see them?"

Sneaked out at 3.30 a.m to deliver this letter to
Patterson's Patisserie. Must get a long telephone
extension tomorrow.

Saturday DEC
(07-268)

I've been running over the details of the case in
my mind. If Mr. Wooton Green didn't do it, how did
he come to own Brumfit's camera? Was he involved
with the angel woman, and if so why didn't he
remove the film and destroy it? Perhaps because
he didn't know there xxx was film in there? I'm
going to have one more try at interviewing him.
I've lost my wig but I still have my beard. An old
hat found in Mrs. E's shed has restored my
disguise to its full.

(Disappointing sex session with plain woman in
anorak on the bus. Sad to note that Doreen was not
at work again. Hope she hasn't left.)

Still no lights on, and no answer when I knocked
on the door. I cupped my hands to the front window
and thought I saw movement among the shadows but
then everything was still. I crept round to the
rear of the house and stood in the back garden
from where I was able to see into his kitchen. It
was dark in there too but there was just enough
light coming from the pantry for me to make out
the figure of the man from Wooton Green, the man
who had sold me the Rolleiflex. His head was
tipped back and he had a small tin of evaporated
milk to his lips.

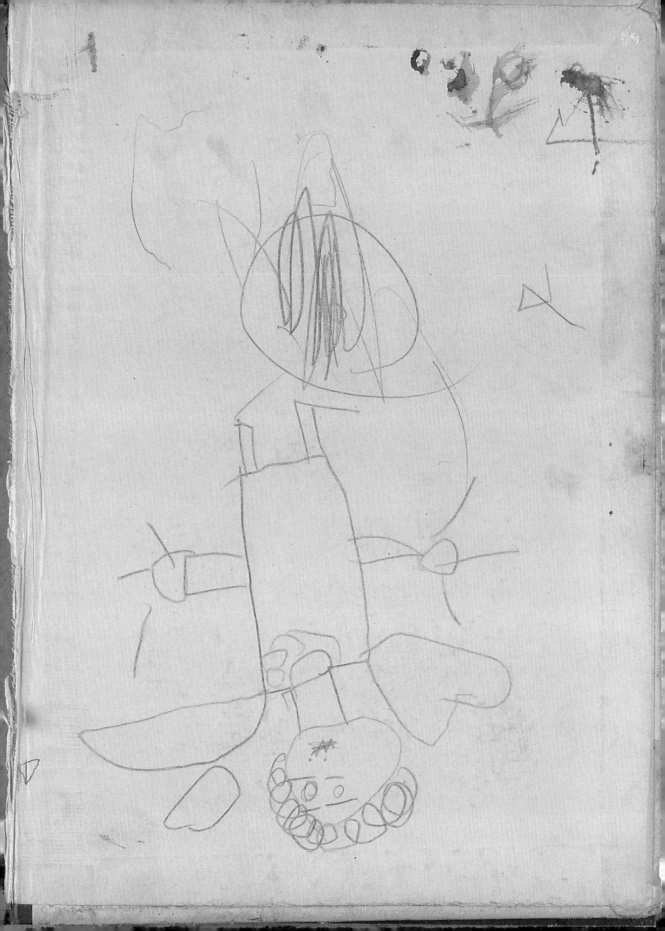

Having spent all that time admiring Doreen from a distance, you'd think I'd know her face back to front but up close she looked quite different. Not like my pictures of her at all. Perhaps it was because she was talking and I've never heard her voice before. I'd imagined her to sound like Greer Garson and she didn't. It was a lot to take in and I must have looked quite startled because for a while I couldn't think what to say.

I'd just got back and was strolling XXXXXXX past the front of my house which I sometimes do to X see if I can spot any police, when I saw someone ringing my doorbell. It was five past six. At first I thought it was Mr. Bone wanting his window cleaning money but as I approached I could see it was a woman. She turned and spoke to me.

"I'm Doreen Collar," she said. "Are you Mr. Whittingham? It's about the modelling work."

After Mrs. Williams' rebuttal I have to confess I hadn't been holding out much hope on the Doreen front, but five minutes later she was sitting on my sofa with a cup of tea in one hand and a Jammy Dodger in the other. A little shoulder bag by her feet.

She could see straight away that I was the consummate semi-professional because after the preliminary niceties I got straight down to business and took her up to the studio. The lights were all set up. Camera, tripod. And what with a selection of nude studies pinned to the board, she had no reason to suspect that I hadn't been at it for years. Couldn't see any sign of police outside but by this time the lights were already on so I'd rather burnt my bridges in that department anyway.

. You ever do any cheesecake?"
"I've modeled brassieres and bathing suits."
Kovacks seemed pained. "They've all modeled bathing suits," he said. "How about nude work?"

make up a posing chart. If you can remember even a few of these things, you'll find a definite improvement in the quality of your pictures.

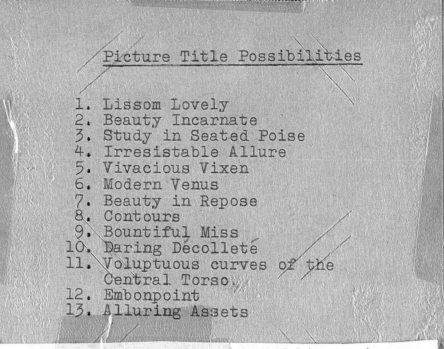

Picture Title Possibilities

1. Lissom Lovely
2. Beauty Incarnate
3. Study in Seated Poise
4. Irresistable Allure
5. Vivacious Vixen
6. Modern Venus
7. Beauty in Repose
8. Contours
9. Bountiful Miss
10. Daring Décolleté
11. Voluptuous curves of the Central Torso.
12. Embonpoint
13. Alluring Assets

When taking nude subjects for reproduction it is better to choose your title first and work to it. As an instance we will assume we are going to take a nude portrait of a girl and entitle it " Humiliation." For this pose we should naturally require one that will live up to the title, therefore, we have to portray unmistakably the meaning of the title. What should we do under these circumstances ?

"If you'd like to undress in here, Miss Collar, I'll pop another bar on. It can get a bit chilly at the back of the house. Just down to your underwear will suffice for this evening I think. If you don't have professional lingerie, perhaps you'd like to try some of these. They should be about your size."

(I'd been in the loft earlier sorting through a few things from the big blue suitcase. There were quite a lot of my mother's things that Nan must have put away after Mum died.)

While she was changing I made use of the time to check through the list of poses I had drawn up.

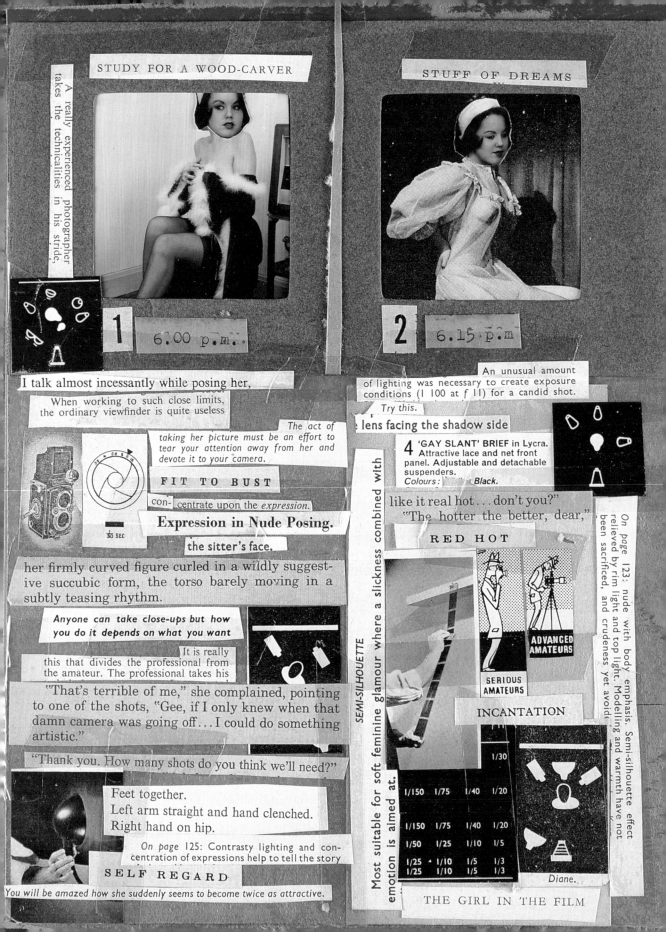

STUDY FOR A WOOD-CARVER

STUFF OF DREAMS

A really experienced photographer takes the technicalities in his stride,

1 6.00 p.m.

2 6.15 p.m

I talk almost incessantly while posing her,

An unusual amount of lighting was necessary to create exposure conditions (1 100 at f 11) for a candid shot.

When working to such close limits, the ordinary viewfinder is quite useless

Try this.

The act of taking her picture must be an effort to tear your attention away from her and devote it to your camera.

e lens facing the shadow side

4 'GAY SLANT' BRIEF in Lycra. Attractive lace and net front panel. Adjustable and detachable suspenders.
Colours: Black.

FIT TO BUST

con- centrate upon the *expression*.

like it real hot...don't you?"

"The hotter the better, dear,"

Expression in Nude Posing.

RED HOT

the sitter's face.

her firmly curved figure curled in a wildly suggestive succubic form, the torso barely moving in a subtly teasing rhythm.

Anyone can take close-ups but how you do it depends on what you want

ADVANCED AMATEURS

SERIOUS AMATEURS

It is really this that divides the professional from the amateur. The professional takes his

INCANTATION

"That's terrible of me," she complained, pointing to one of the shots, "Gee, if I only knew when that damn camera was going off...I could do something artistic."

"Thank you. How many shots do you think we'll need?"

Feet together.
Left arm straight and hand clenched.
Right hand on hip.

On page 125: Contrasty lighting and concentration of expressions help to tell the story

SELF REGARD

You will be amazed how she suddenly seems to become twice as attractive.

SEMI-SILHOUETTE

Most suitable for soft feminine glamour where a slickness combined with emotion is aimed at.

On page 123: nude with body emphasis. Semi-silhouette effect relieved by rim light and top light. Modelling and warmth have not been sacrificed, and crudeness yet avoide

| | 1/30 | | |
|---|---|---|---|
| 1/150 | 1/75 | 1/40 | 1/20 |
| 1/150 | 1/75 | 1/40 | 1/20 |
| 1/50 | 1/25 | 1/10 | 1/5 |
| 1/25 | 1/10 | 1/5 | 1/3 |
| 1/25 | 1/10 | 1/5 | 1/3 |

Diane.

THE GIRL IN THE FILM

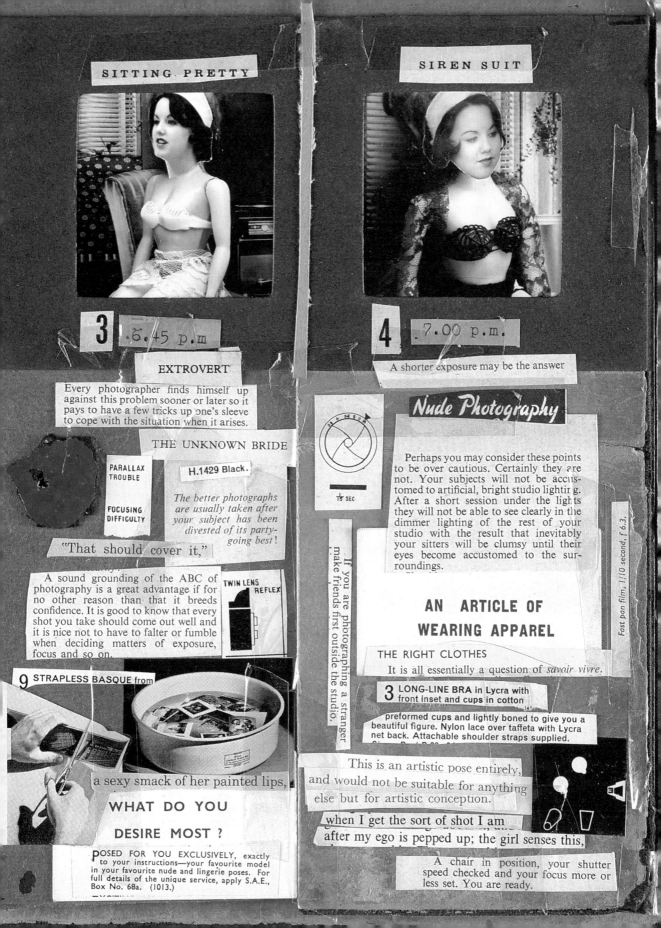

SITTING PRETTY

SIREN SUIT

3 .6.45 p.m

4 .7.00 p.m.

A shorter exposure may be the answer

EXTROVERT

Every photographer finds himself up against this problem sooner or later so it pays to have a few tricks up one's sleeve to cope with the situation when it arises.

THE UNKNOWN BRIDE

PARALLAX TROUBLE

H.1429 Black.

FOCUSING DIFFICULTY

The better photographs are usually taken after your subject has been divested of its party-going best!

"That should cover it,"

A sound grounding of the ABC of photography is a great advantage if for no other reason than that it breeds confidence. It is good to know that every shot you take should come out well and it is nice not to have to falter or fumble when deciding matters of exposure, focus and so on.

TWIN LENS REFLEX

9 STRAPLESS BASQUE from

a sexy smack of her painted lips,

WHAT DO YOU

DESIRE MOST ?

POSED FOR YOU EXCLUSIVELY, exactly to your instructions—your favourite model in your favourite nude and lingerie poses. For full details of the unique service, apply S.A.E., Box No. 68a. (1013.)

75 SEC

Nude Photography

Perhaps you may consider these points to be over cautious. Certainly they are not. Your subjects will not be accustomed to artificial, bright studio lighting. After a short session under the lights they will not be able to see clearly in the dimmer lighting of the rest of your studio with the result that inevitably your sitters will be clumsy until their eyes become accustomed to the surroundings.

If you are photographing a stranger make friends first outside the studio.

Fast pan film, 1/10 second, f 6.3.

AN ARTICLE OF
WEARING APPAREL

THE RIGHT CLOTHES

It is all essentially a question of *savoir vivre*.

3 LONG-LINE BRA in Lycra with front inset and cups in cotton

preformed cups and lightly boned to give you a beautiful figure. Nylon lace over taffeta with Lycra net back. Attachable shoulder straps supplied.

This is an artistic pose entirely, and would not be suitable for anything else but for artistic conception.

when I get the sort of shot I am after my ego is pepped up; the girl senses this,

A chair in position, your shutter speed checked and your focus more or less set. You are ready.

She'd mentioned having to be somewhere later so I didn't know how far I could hope to get. I was actually starting to feel a bit dizzy.

When she came out she was wearing a dressing-gown thing. She seemed a little shy at first which made me feel a bit better. I busied myself with the light meter, masking any embarassment with my professional air.

"Where's the camera?" Johnny barked, ignoring the half soused undulations of Honey's now prone anatomy.

There was something missing. For a moment I couldn't put my finger on it. Then I realised. Allure.

Under the stark light of the studio her face somehow lacked the joie de vivre characteristic of the continental charmer, so with bits and pieces from her make-up bag I tweaked and teased until I had created the lissom shamelessness of the boudoir conquest.

Once I had her in the lens I began to teach her the secrets of inflaming a gentleman's passions with an eager to please look that satiates every voluptuous demand.

The front view, approaching Johnny in her deliberately seductive gait, holding herself back in a suggestively succubine position, brought on another bewildering admixture of emotion. The girl was a modern day Delilah, a temptress who could eke out the most violently virific feeling in a man. But compounded with this most basic urge

welling up in him, Johnny was distraught still over his complete nakedness of thought. It was a curiously discomforting trade this girl had managed—stripping herself to the physical nudity Johnny clamored for, but at the same time exposing his own innermost tricks and ruses to her view.

I can't recall now whether I
organised the first pose or whether
she took this upon herself, but I
do remember the dressing-gown had
gone and I vaguely caught a glimpse
of black lingerie.

Through the camera it looked like the exact
same outfit as in 'Beauty Unadorned' though at
the time I couldn't work out how it could have
been. The blouse was actually yellow. In
colour everything had somehow come to life.
Then before I could focus properly she'd
adopted the same pose, perched on the back of
the chair, hands on hips, looking seductively
into the lens.

CAMERA-EYE

Her whole manner was an invita-
tion to be touched, to be held, to be kissed.

Part of me wanted her to stop. To
cover herself up. But at the same
time I knew that as a semi pro-
fessional glamour man it was my
duty to capture her on film.

If the model is not as you desire her, you must of course see that you get
her into that pose. Do not be afraid of re-arranging her if it does not come
up to your expectations.

It's hard for me now to remember exactly how
it all happened. I think I was leaning forward
to tease her coiffure or something when there
was a flash and I realised I'd accidentally
taken a picture before I was ready.

Training the Model to Pose

when you say 'Yes, like that, please',
the shot is taken immediately. Fire the shutter to
accustom her to the sound, and thus avoid
blinking. Flash is always frightening at first to
models who are unaccustomed to it, and
if you use bulbs, it is worth while wasting your
first picture to give her a trial run. She will
be scared by the flash and convinced that she
blinked in the middle of it.

The flash must have startled her because she
started screaming and beating me about the
head with the flat of her hand.

"Stop it! Stop it!" Marla screamed, pulling away
and trying to flail out at him with her delicate arms.
"Hard...hard to get, huh?" Johnny mumbled out
of breath, savoring the choice view of actively roun-
ed hips and thigh tops when he ripped off the red
briefs.
"You're—you're *vile!*"
"We won't go into that. We'll be more practical, chick.

119

I tried to calm her down, worried what Mrs.
Eckersby would be thinking, but she started
struggling and pushed her way past me. I don't
know quite what happened then, everything became
rather confused. Somehow Mum's blouse got ripped
and in the scuffle I inadvertantly trod on my box
of film (Ilford FP3). Before I knew it she had

run out into the street. There was nothing I could
do to stop her.

I didn't know what to do then. After all the
commotion everything seemed quiet and still. I
turned out the studio XXX lights and shut the door
behind me. Before leaving the house I took my
camera up into the loft and hid it in the blue
suitcase. I've left the film in it. There's just
the one picture. Someone else can deal with that.
From a technical standpoint I wouldn't have minded
seeing how it came out but it's a bit late for
that now. Anyway I'm not sure it's something I'm
supposed to be looking at.

So now I'm back in XX Mrs. Eckersby's shed. I'm
not hiding anymore, I just want to finish up my
diary before the police come. I don't expect XXXX
they'll let me keep it. There's a whole dossier
of evidence here but I don't suppose it would do
any good to show it to the police. No point in
telling them that the fire was an accident, that
I was only six when Brumfit was killed. They
believe what they want to believe. Once they've
made up their minds you're guilty there's nothing
you can do. I'm not bothered anyway. Someone has
to pay for the wrongs that have been done and it
might as well be me.

I suppose Brumfit got what he deserved. If I'd
examined the evidence more carefully I would have
known it could only come to this. You can't
follow in someone's footsteps without going down
the same road.

When I came back to the shed I found this envelope propped up against my typewriter. The message on the front is a piece which has been cut out of one ᵡᵀ of my books, 'Lens Lust' if I'm not mistaken. So I was right, Someone has been coming in here and now I can guess who. I noticed the letter straight ᵡᵡᵡᵡ away but I've decided not to open it. I don't want to know what's inside. Not now. It's not that I really blame anybody, I just don't want to hear about it, that's all.

THE END

It was the Grigori, or 'Watchers' who first taught women how to use cosmetics, perfumes and fine silks to inflame a man's passions.

These Angels who fell from heaven saw the daughters of Caine perambulating and displaying their private parts, their eyes painted with antimony in the manner of harlots, and, being seduced, took wives from among them. The Watchers, ever susceptible to a friendship of the thighs, had become voyeurs.

The Grigori serve eternal imprisonment as punishment for what they did with the daughters of man. It is here in a penal area within the 5th heaven that these gigantic fallen angels crouch in everlasting despair.